This book is dedicated to raising awareness about climate change. If I am able to start a process by helping only one person make some changes, it will have been all worth it - because even one more voice will ultimately make a difference.

D1312515

Ecosynergy Creative

30 Aurora Tce, Hillcrest, Hamilton 3216 New Zealand

Janson, Yaniv Daniel

Changing the World - One Painting at a Time

1. Art

2. Title

First edition: ISBN: 1451547013 EAN-13: 9781451547 016

Graphic design: Sufa Berman Bareket

Language: English Soft cover, 40.64 × 25.4 cm.

Printed and bound in the United States of America (August 9, 2010)

Acknowledgments

Deepest thanks to Marcel Baaijens, Distance Delivery Mentor, The Learning Connexion, for his support with this publication and his unfailing encouragement; and to Sufa Berman Bareket for her personal commitment and involvement in designing and producing this book - they are precious colleagues and mentors.

Heartfelt appreciation to the Variety Gold Heart Scholarship Programme (variety.org.nz) for providing the funding towards the Climate Change Project.

Introduction

A woman seeing Yaniv Janson's painting 'Houses of Poor and Rich People' exclaims:
"The house in this painting was my life while growing up. My mother was a solo mum struggling to raise us, but her resolve helped us get through to a coloured house – this one!"

She like many others observing Yaniv's art, finds that it strikes a chord with an intangible yet familiar emotional identification. These experiences where something has been touched inside, often manifest as verbal gratitude or long heartfelt hugs.

Another exhibition visitor exclaims, while looking at the painting named "My Black and White Life in Colours":
"This is the way other people want me to live my life – in a house that is only black and white, the 'normative' way, and I want to live in a rainbow house, with all the colours of the spectrum – just like the gay flag. This is a painting about my life"

People identify with Yaniv's paintings in ways that are new to them. They buy his work because they feel it was created especially for them and expresses their story. Others connect strongly with issues prevalent in his current work: the problems humanity faces with global warming and the melting of the ice caps. Consequently, Yaniv is often invited to exhibit.

His ability to connect with his audiences through visual language is remarkable considering the fact that the artist has a condition that in daily life impairs his ability to express emotions through verbal language. Yaniv has Aspergers' Syndrome, otherwise known as 'high functioning autism'. His older brother remarked that when Yaniv started to paint he was surprised at the range of bright colours he splashed on the canvas – seemingly paradoxical, and in contradiction to the monotone speech and 'black or white' language used to describe the world around him. Sharing emotions and communicating are not Yaniv's strengths, certainly not with strangers to whom he is not attuned. In any event, interactions with others were kept to a minimum, resorting to stereotypical language. Art has given him a new language, a new mode of expression, a focus, and perhaps a new dimension to his life.

As he matures as an artist, day to day interactions with others are slowly enhanced. Success breeds success - as he begins to realise that the people around him are attracted to his art, he opens more and more to others. His interests have widened with diverse new experiences being channeled through art – increasingly, topics such as Architecture, Science, Fashion and Nutrition… become part of his realm.

Yaniv's parents are thrilled at the impact art is having on his life and the visible effect it has on him. They recount that this success often requires huge efforts on different levels: helping with the logistics of exhibitions, mediating with organizations, explaining situations that are foreign to him e.g. how to develop any career from the ground up. This energy input, however, is small in comparison to the *joie de vivre* that success is having on him.

"*I'd rather invest the effort upfront (in helping him succeed) than in retrospect (in dealing with the boredom that would result from not having such a major interest and passion)*" *says his mother.* "*I spend inordinate amounts of time upskilling in arts, an area that was foreign to me. I was more familiar with aspects of career development and marketing so I became his informal assistant and manager, allowing him to concentrate on his creative process. This is both draining and energising, but I never tire — drawing enormous amounts of strength from being around him when he is creating, and from introducing his art to new situations. It is literally uplifting. It is my battle — but his victory*" she concludes.

In the first 20 months of his painting career, Yaniv featured in 19 exhibitions, 6 of these as a solo artist and sold over 70 paintings in the USA, Europe, New Zealand and other parts of the world. Five more national and international exhibitions are planned for 2010. Such an instant success is a rare anomaly in the art world.

Yaniv's budding talent has been recognised as being part of the "talent pool" in his adopted New Zealand by arts critics, museum and gallery curators, awards judges and established artists, some of whom have mentored him.

Within months of painting his first canvas, he was selected as a finalist for two of the most prestigious contemporary art awards in New Zealand. Yaniv was the youngest artist in both. In the following year, he received more awards and scholarships to pursue his studies at the The Learning Connexion, the International School of Arts and Creativity in Lower Hutt near Wellington in New Zealand. He now has an exhibition in Paris... all before turning 18.

His talent is recognised not only in the art world but also in other areas. There are architects who enjoy his urban landscape paintings and fashion designers who are inspired by his drawings and look forward to working on collaborative projects.

Initially his close family was concerned that his success was possibly out of sympathy because of his autistic label; however, as the appreciation and recognition continued, it became clear that his success is due to his artistic talent.

Art by artists with special needs often appeals to society at large and their work is sometimes labeled as visionary.

Could it be that autistic artists represent different points of view? We know that people with autism process incoming information differently from those without autism. Maybe this informs a view of life and the world that those without autism are unable to see and express. People with autism may not be able to express this difference through verbal or written language as they may not be conscious of this difference, but maybe their artistic expressions have the ability to reveal such differences through visual language.

Today, Yaniv concentrates on raising climate change awareness and seeks to move audiences and create impact through the visual educational installations which he would like to exhibit in New Zealand and abroad.

"Solving climate change issues implies behaviour changes" (Al Gore). Current campaigns are important, however, they have failed to reach a sizeable proportion of hearts and minds! In order to maximise the impact of these messages we must go beyond scientific rationale and appeal to all senses — not just our intellect. This is where Yaniv creates his special connection with his audience. His aspiration is to spread the word through multiple channels to generate reactions strong enough to change behaviours. This will be done by using education and visual language to pose questions with an emotional impact: what will cities and landscapes look like if we continue on this unchanged path? Some areas will be much colder, in others, temperatures will rise with terrifying consequences for all. It is time to illustrate with images what our earth will suffer and what the impact on people will be — before it is too late to revert! That the will to spread this vital message has empowered him to develop an alternative visual communication channel is a feat in itself.

Yaniv's pathway is not only his own — he is a representative of many others who, because of unusual circumstances are in danger of marginalisation. His success is a powerful message of hope to all 'special needs' people and their families - that having a disability does not exclude the presence of extra-ordinary abilities and that living with such a life challenge does not preclude the will and possibility to spread political and social messages and lead significant change movements.

Annick Janson

A different perspective

It is my pleasure to introduce Yaniv Janson's second book.

As an artist, I have enjoyed observing his increasing artistic skills. In my judgement Yaniv has an innate colour sense and from the beginning has achieved strikingly effective colour combinations. Through diligence and tuition, Yaniv has become more skilful in a number of techniques of his craft. One thing that is noticeable is that he is using his art to express ideas that are important to him more subtly and effectively as his mastery of the craft increases.

I knew Yaniv before he started painting, and at the beginning of his artistic endeavours, and have enjoyed watching his development over the years. When he first started painting his art was his main communication tool that he used with people he wasn't close to. As his skill and output grew he began to engage in conversation and work alongside people he was unfamiliar with. Over the two years he has been painting he has matured in self-confidence and communication skills. In the preparation of a new gallery space for the WSA National Youth Art Award 2009 he was a valued member of the team.

He is extremely focused and self-directed, and very diligent. He is a regular exhibitor with the Waikato Society of Arts. Amongst others, he was a finalist in the National Contemporary Art Award and the National Youth Art Award run by WSA and the Waikato Museum and has an impressive bio. The sheer output is unusual in one so young and being a finalist in a number of prestigious New Zealand awards is testimony to his talent.

Martha Simms
President
Waikato Society of Arts
12 February 2010

I am one of those people who think they are going to get what they want…

"I paint to raise awareness about the impact of global warming on the environment and on city life, because our landscapes will face unprecedented challenges.

Millions of years ago mountains rose from the sea. In our era, the opposite is happening - land disappears before our eyes. If we don't act now, we will end up looking at trees on billboard and shop windows...

Since 75% of the world population lives within 150km from the seashore, melting glaciers causing rising sea levels might leave many people homeless in the next decades. Weather extremes such as Hurricane Katrina in New Orleans, and tsunamis such as the Pacific ones left many people without homes.

My paintings speak for the people yelling for help that nobody hears, even as seas rise to engulf their houses.

Some say that we are going to need a bigger boat than Noah's Ark.

A global audience can help spread a movement by which artists could take a message to the world in a universal visual language.

New Zealand is one of the only countries in the world that invites refugees from Pacific islands where the danger from rising seas is only decades away... I am proud to play even a small part in this relief effort.

Also, my hope is to help add to this effort in further raising awareness about the associated causes.

All children of the world – unite and make sure your parents know that you care!!!

I have undertaken a number of Art for Education projects that raise awareness about social and environmental issues from art.

This passion keeps me going through the ebb and flow of the artist's career."

Statement of artist Yaniv Janson for the 2010 submission to the Waikato Museum Artpost Gallery

Colours of changing landscapes

Pollution - at the very end the land could become red or otherwise purple/black and the ocean could become black - how would we feel then?

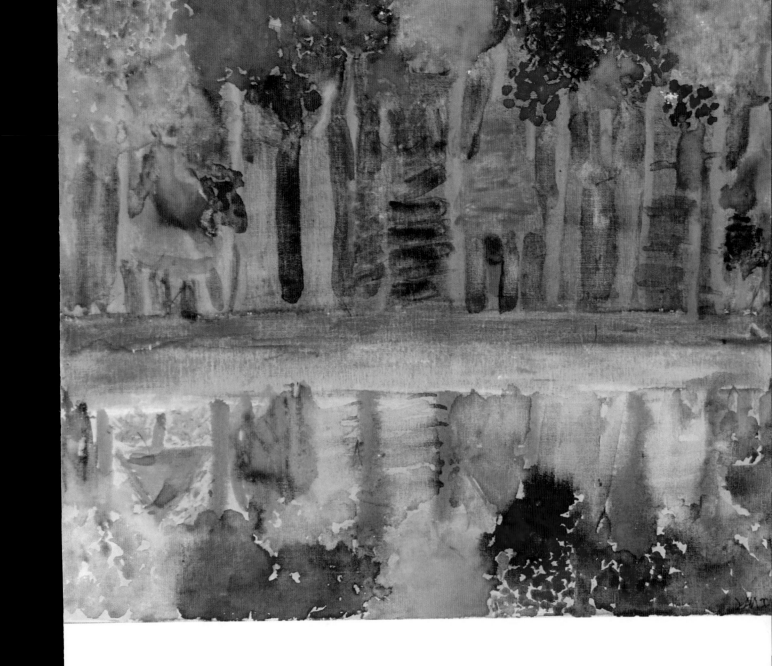

Blue In Autumn, 2008

Water colour on canvas

Size 60 X 50 cm

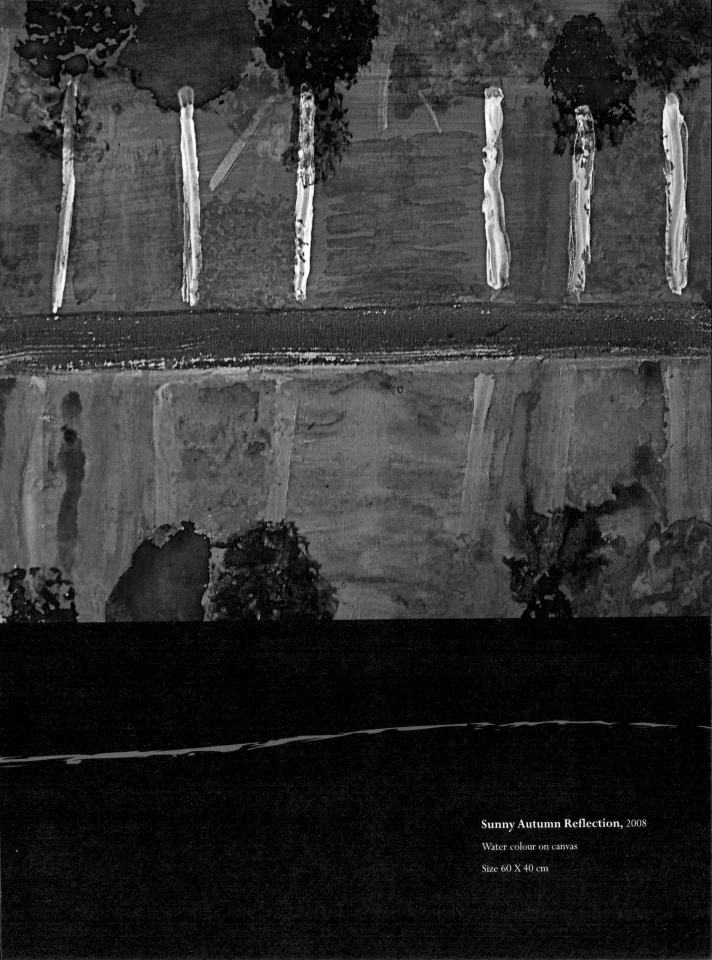

Sunny Autumn Reflection, 2008

Water colour on canvas

Size 60 X 40 cm

Autumn Fires, 2008

Water colour on canvas

Size 60 X 40 cm

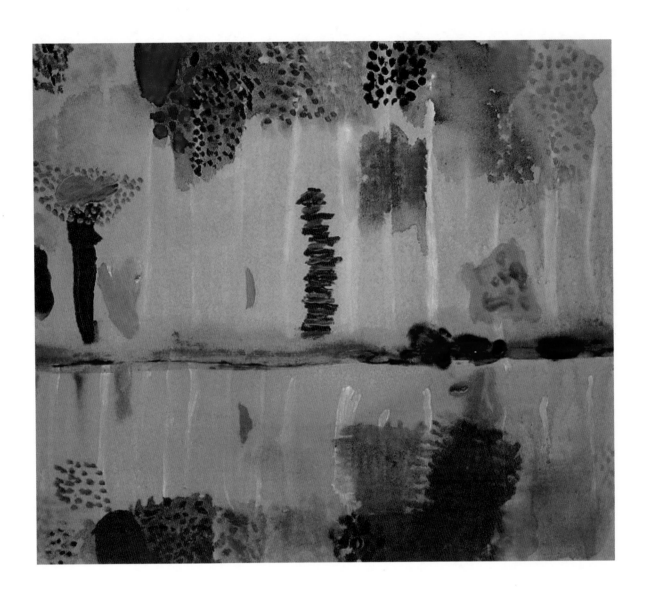

Michele Autumn Blue, 2008

Water colour on canvas

Size 60 X 40 cm

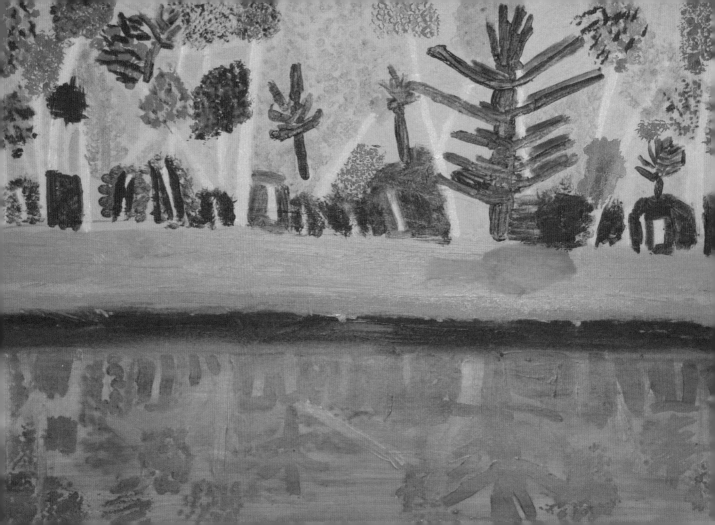

I liked the colours of the trees, especially by the lake. I'd been hearing about reflections and seeing some around me. The yellow background is lightened by the sun - which is a special colour in autumn - I had to look for a long time for that particular yellow...

Autumn Reflections, 2008

Acrylic on canvas

Size 120 X 70 cm

Next page:

Sun All Day Long, 2010

Acrylic on canvas

Size 120 X 70 cm

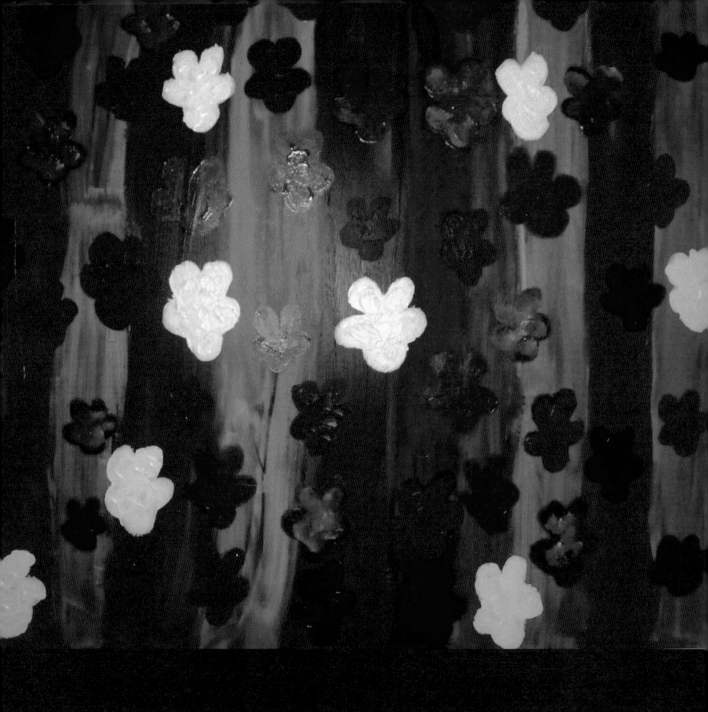

Yesterday, Today and Tomorrow (1), 2009

Acrylic on canvas

Size 90 X 90 cm

Flowers have a personality - and a 'strongness' about them.

In a painting I try and think about each flower - are they happy or OK or sad? Then I can paint each one according to its emotions.

If the temperature changes globally, this will have an effect on the plants around us - this is why I painted the white ghosts of flowers, that will no longer be around... they will have disappeared.

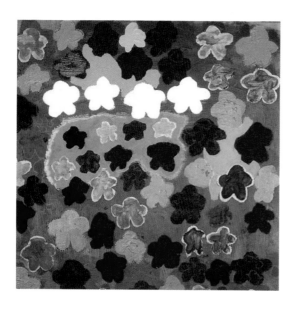

Ghosts of Yesterday, Today and Tomorrow (2), 2009

Acrylic on canvas

Size 90 X 90 cm

Ghosts of Yesterday, Today and Tomorrow (3), 2009

Acrylic on canvas

Size 90 X 90 cm

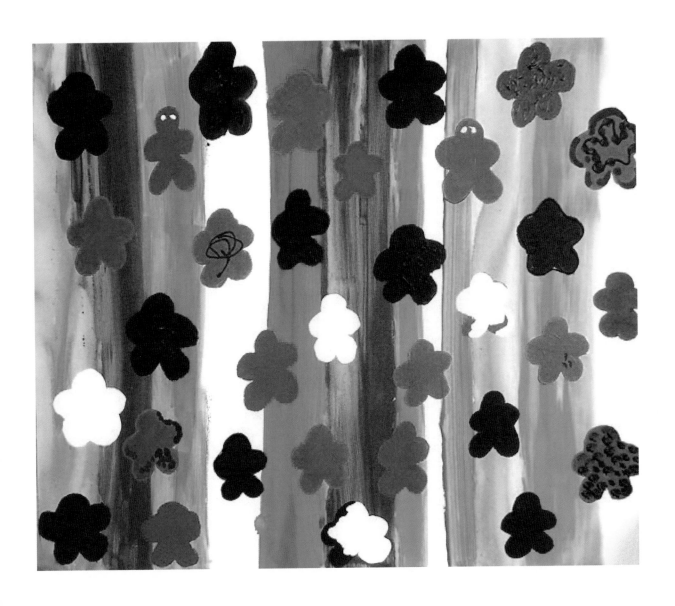

Ghosts of Yesterday, Today and Tomorrow (4), 2009

Acrylic on canvas

Size 90 X 90 cm

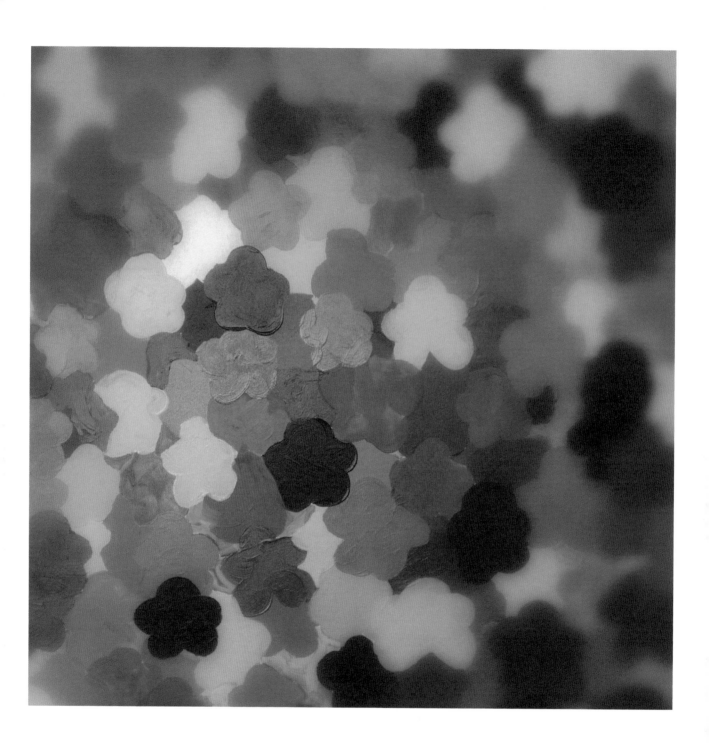

Black and White in Colours, 2010

Acrylic on canvas

Size 90 X 90 cm

The flowers in the middle are rainbow colours.

I finished that one just before putting my paintings up on the wall of an exhibition.

I was thinking about the flowers called "yesterday, today and tomorrow" which are three different colours - they go from light to dark purple in three days.

How would it be if there were flower colours for each day of the week - starting with red and ending on purple, just like rainbows?

Here, as you get away from the centre, they get fuzzy - there are in danger of loosing their colours if the weather conditions change.

Water

The painting "One minute before the tsunami" shows a very peaceful landscape with calm atmosphere, with dolphins jumping in the water and beautiful gardens with great views. The people don't know that the tsunami is coming but we know how much destruction could result.

Water is an important element for life and the problem with changes in the climate is that no one can predict what will happen to this resource, and what even a few degrees change will create. Rising sea levels and possible tide changes can create havoc in our environment.

One Minute Before The Tsunami, 2009

Acrylic on canvas

Size 90 X 90 cm

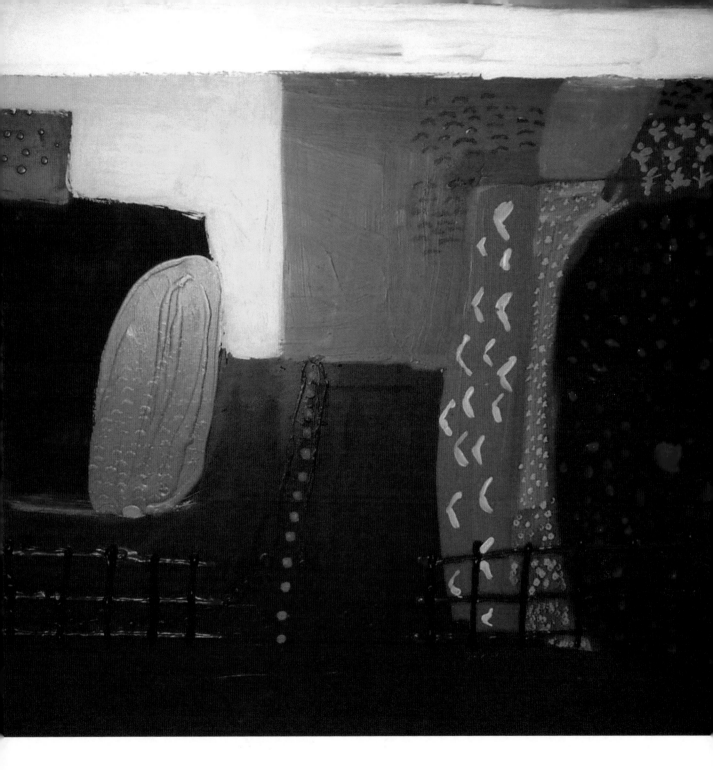

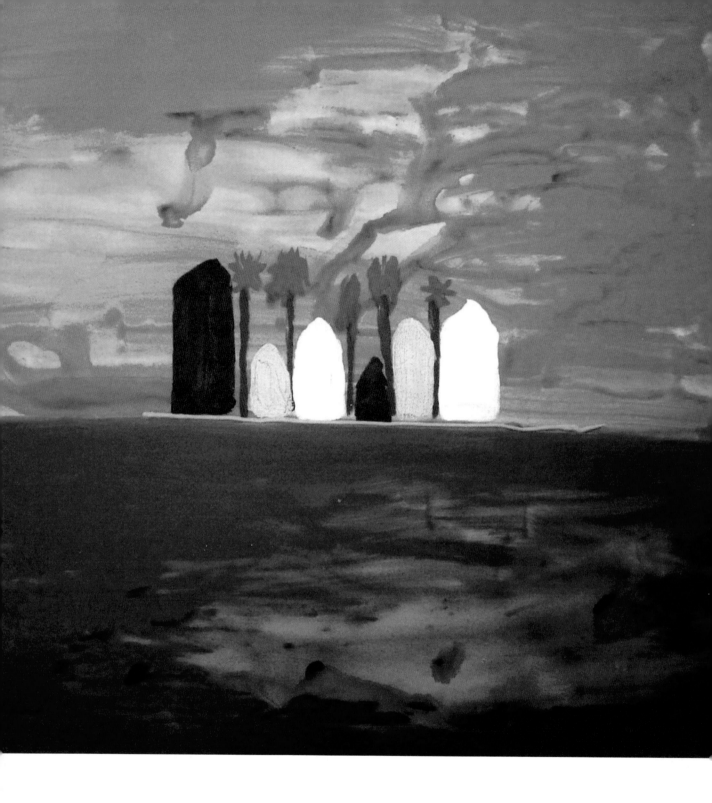

Floating Islands, 2009

Acrylic on canvas

Size 90 X 90 cm

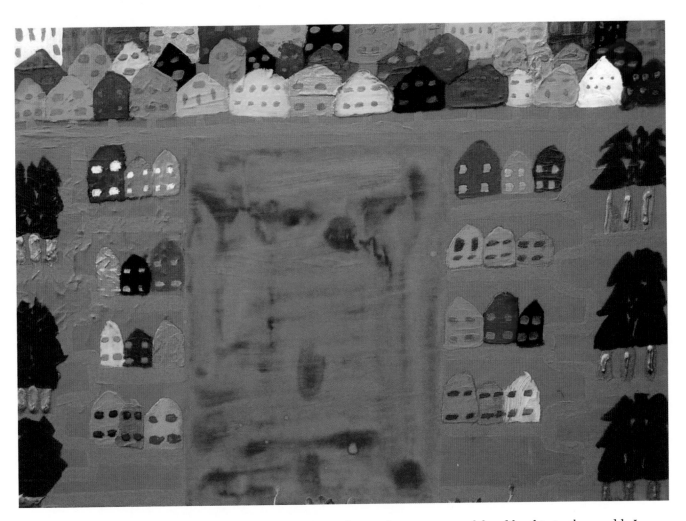

I sometimes like to think of square lakes. I know there are some lakes like this in the world. I painted this one a square so that people can imagine what it would be like to live in this landscape.

It can be nice for people to swim in - for playing games in the summer. When people play 'Marco Polo' in a pool that is not straight - they are never sure they are going the right way. In a square lake, people who are chasing others find it easier to catch them if they want to win. They can swim in a straight line and it is much easier. We just have to make sure the water stays light or medium blue as unpolluted as possible.

Square Lake, 2009

Acrylic on canvas

Size 60 X 60 cm

These paintings are called "How long till the water rises?" because some of these houses are going to disappear under water in our lifetime. The people who are going to lose their houses need our help right now.

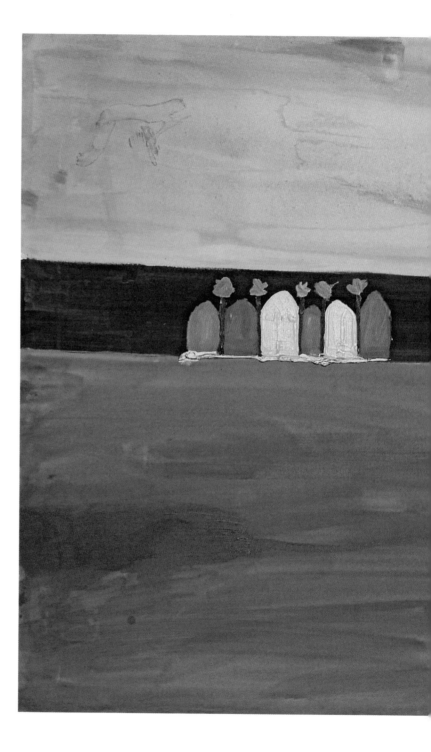

How Long Till the Water Rises, 2009

Acrylic on canvas

Size 120 X 70 cm

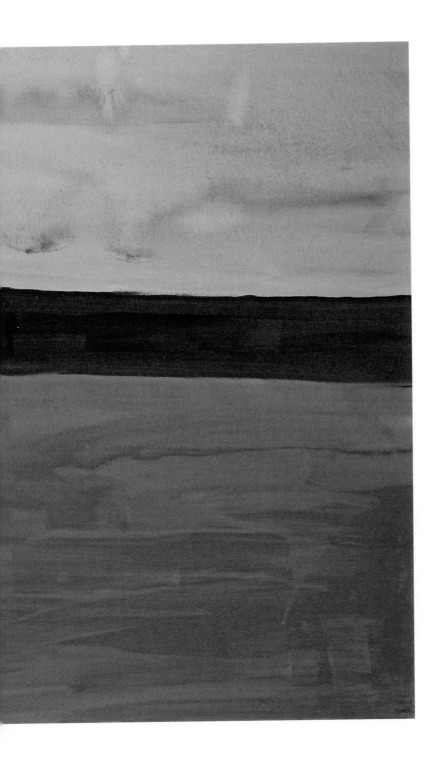

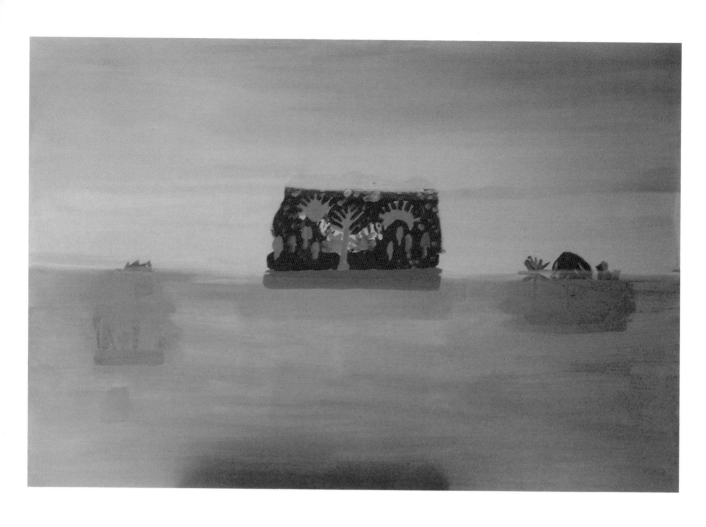

Untitled, 2010

Acrylic on canvas

Size 133 X 102 cm

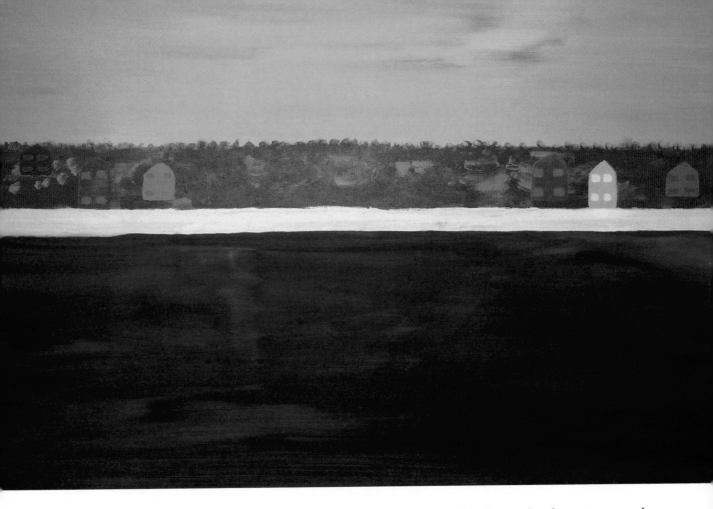

The Invisible Danger painting is about people not knowing that the sea levels are rising and that they are in danger. They know they need to do something about that before it is too late but other people in the world do not want to think about flooding islands…

It is very sad that people do not pay attention to what's happening on islands that are flooding.

Invisible Danger, 2010

Acrylic on canvas

Size 133 X 102 cm

This blue painting is viewed from inside the ocean - the ocean has waves that travel to many parts of the earth. The ocean is the home of species that have not even been named - yet are in danger of extinction.

And the ocean is warm in some places and cold in some places and deep in some places and not so deep in other places.

Blue is the world's favorite colour

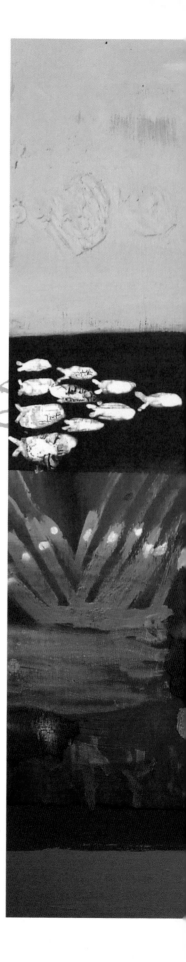

BLUE IS EVERYTHING - THE ULTIMATE COLOUR...

Plancton, 2010

Acrylic on canvas

Size 90 X 90 cm

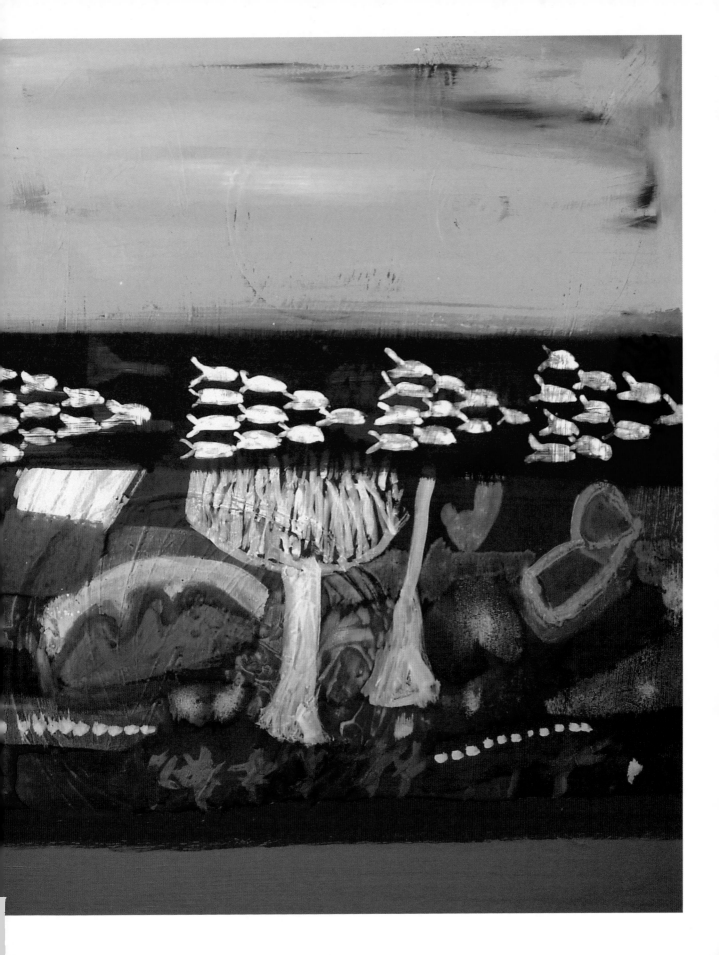

Stronger weather extremes

When I look at the paintings, the mountains are not straight, it looks like the world is about to flip over and lots of people will die. Each mountain is not in a straight line. When people look up from bottom to top, it feels like they are not on flat ground. It makes me feel uncomfortable… with climate change it could be that the ground will no longer be as safe as we are used to.

The paintings with houses and wind patterns in the front show serious storms developing that keep changing direction North-East/West-South — sometimes they go in circles, sometimes in other shapes, forwards and backwards.

In some places, the environment is getting cooler, in others the ice is melting. All the cold water mixes into the seas causing surprise floods and horrendous damage. In other places it could be getting as hot as a sauna — pools outside unheated in the winter, temperatures as hot as coffee or as cold as ice cubes.

Let's get back to unpolluted times — with the ozone protecting the earth from the sun's rays coming on too strong for the earth. What can we do against that? We can make the decision to pollute less!

Catching buses, walking, biking, roller blading, skating every day are good ideas to decrease pollution. Children have an important role to play in helping convince their parents to pollute less.

All children of the world — unite and make sure your parents know that you care!!!

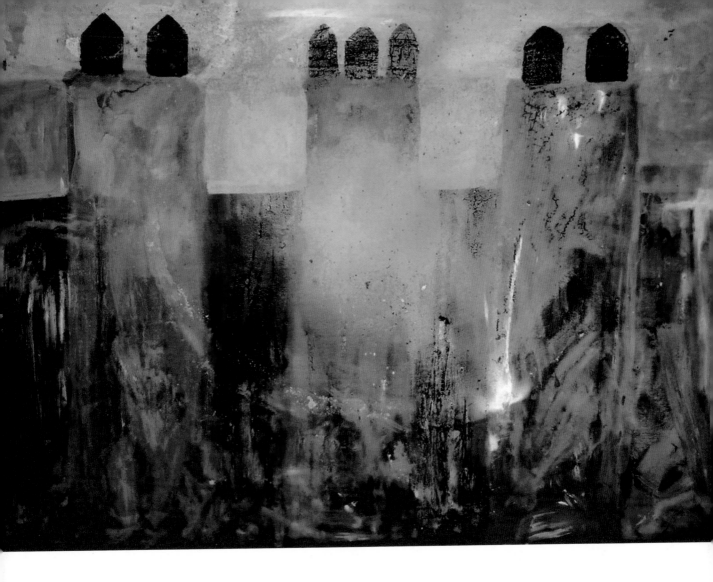

Atlantis Rising, 2009

Acrylic on canvas

Size 120 X 92 cm

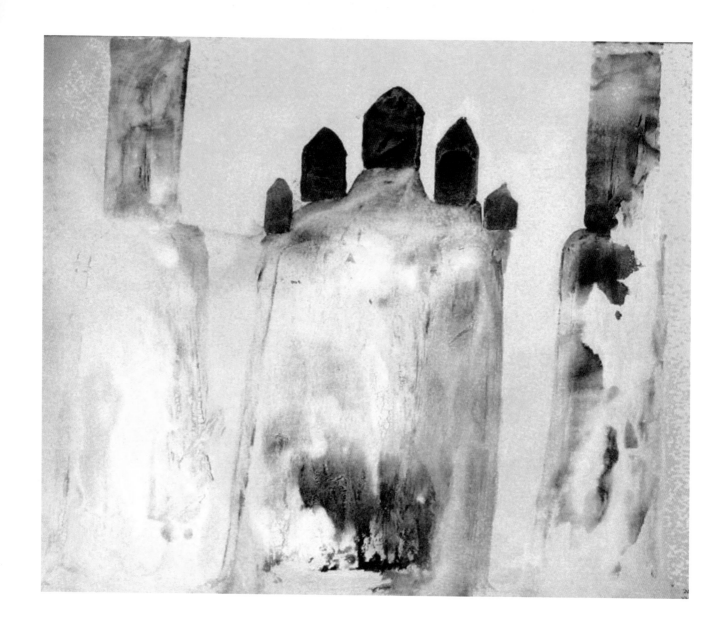

White Blizard, 2009

Acrylic on canvas

Size 86 X 76 cm

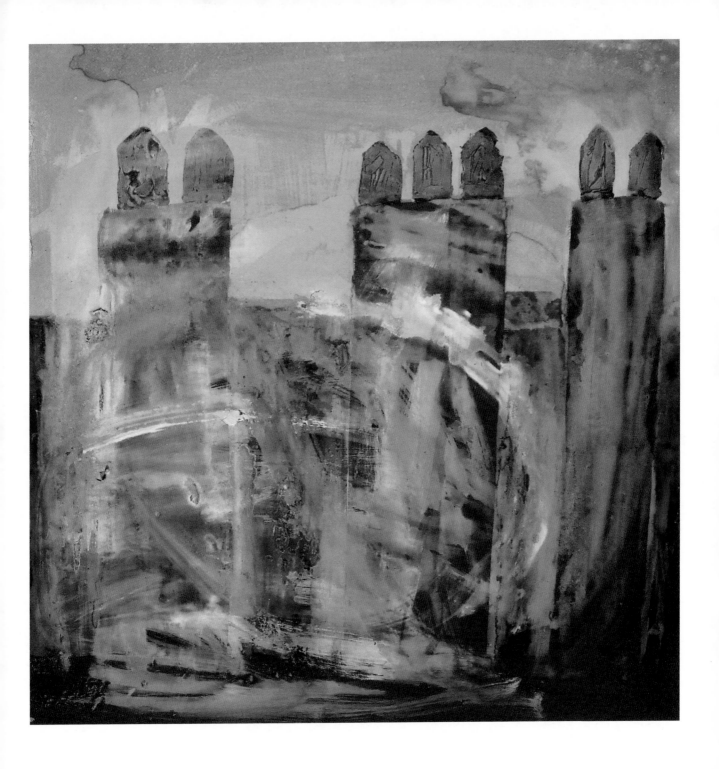

Tornado, 2009

Acrylic on canvas

Size 76 X 76 cm

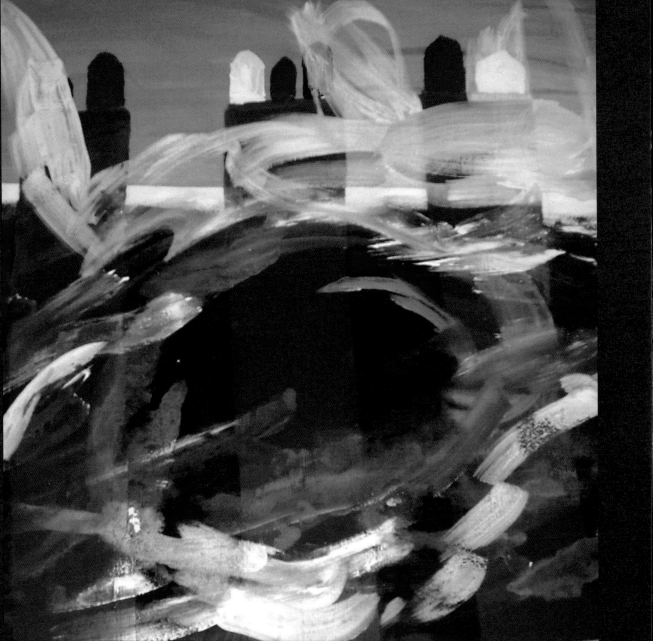

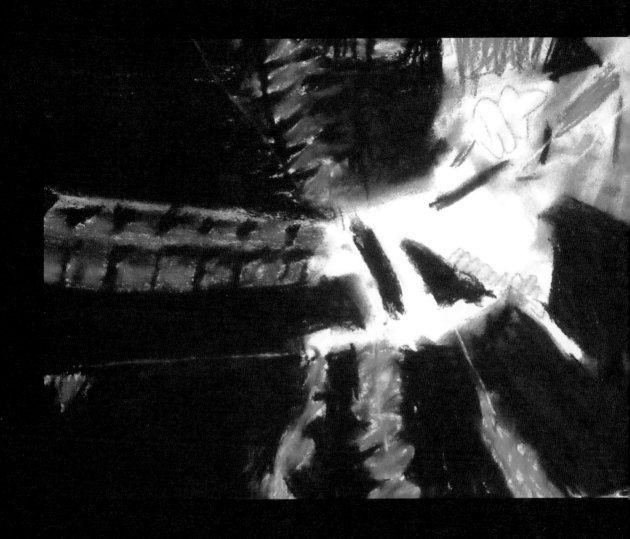

Pandora Climate Change, 2010

Pastel on paper

Size 40 X 21 cm

Melting Ice Cap, 2010

Acrylic on canvas

Size 150 X 120 cm

45

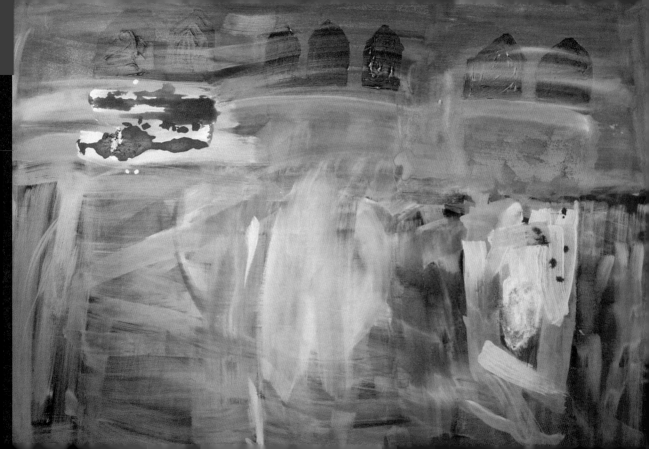

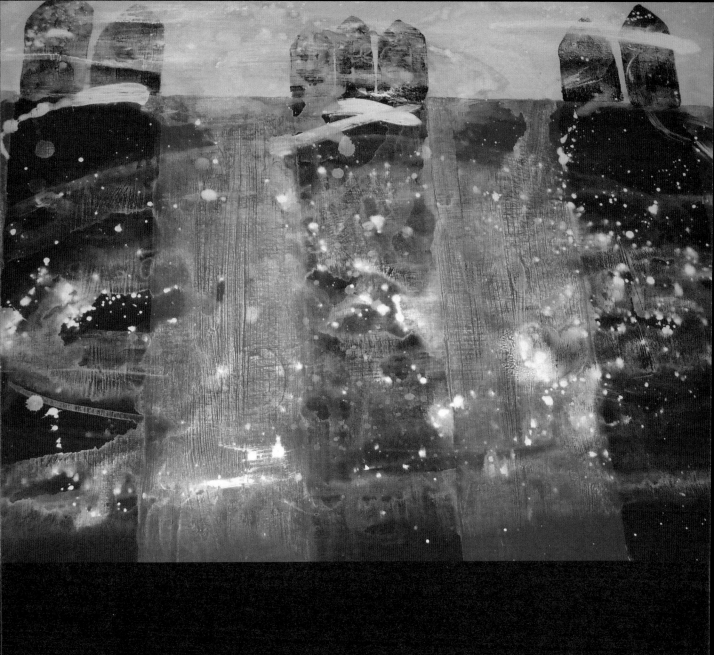

Houses In The Snow, 2010

Acrylic on canvas

Size 120 X 70 cm

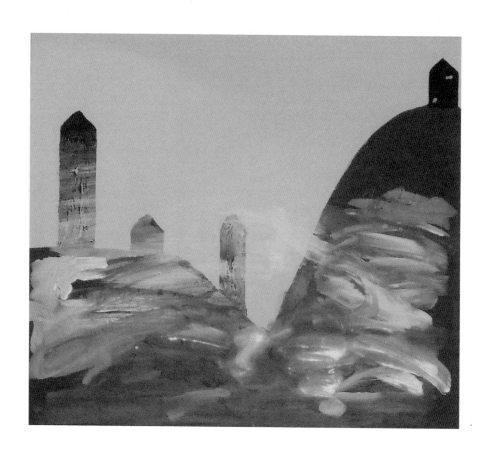

Beacon on the Hill, 2009

Acrylic on canvas

Size 100 X 80 cm

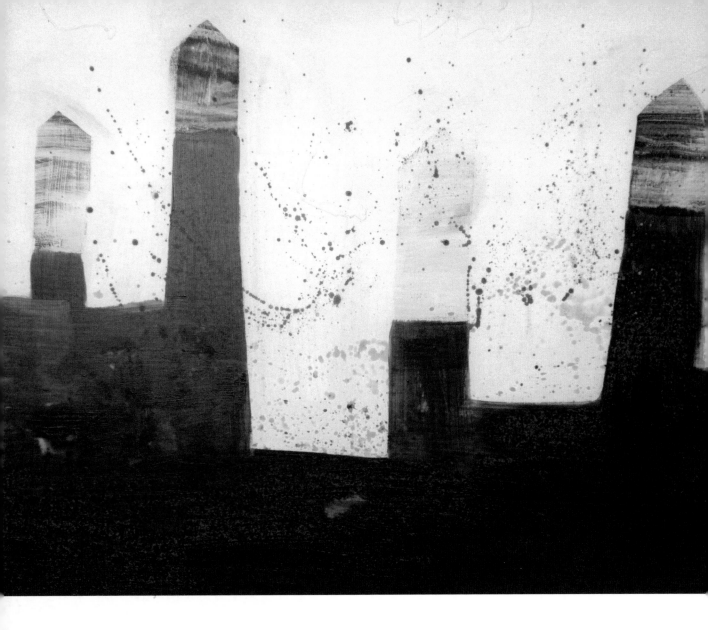

A Huge White Storm Coming, 2010

Acrylic on canvas

Size 100 X 80 cm

Man made disasters

Vegetation changes and becomes more sparse…
Clear water turns green from algae…
…What do we want the world to look like in the future?

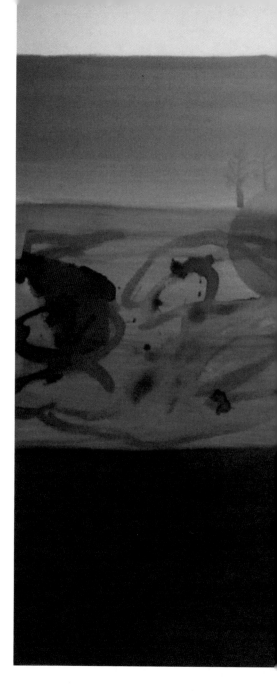

Lost World, 2010

Acrylic on canvas

Size 150 X 120 cm

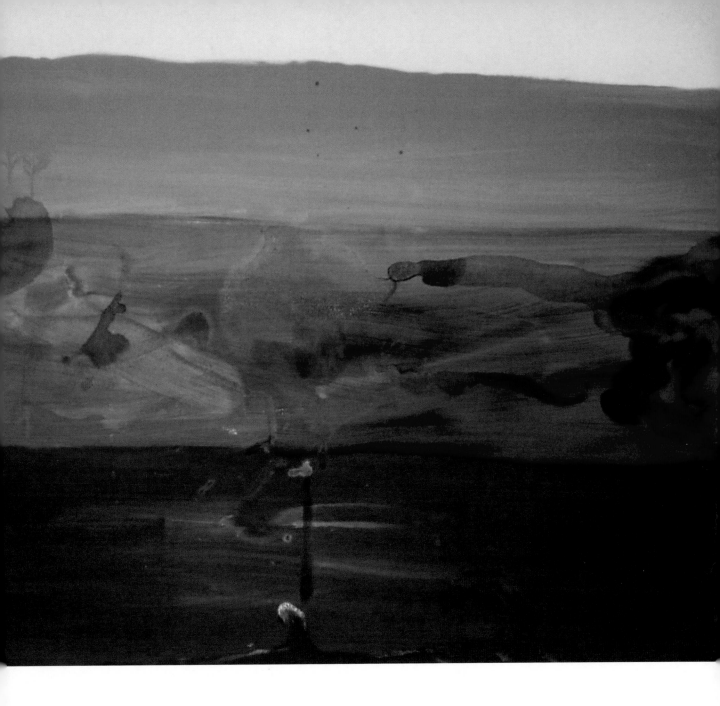

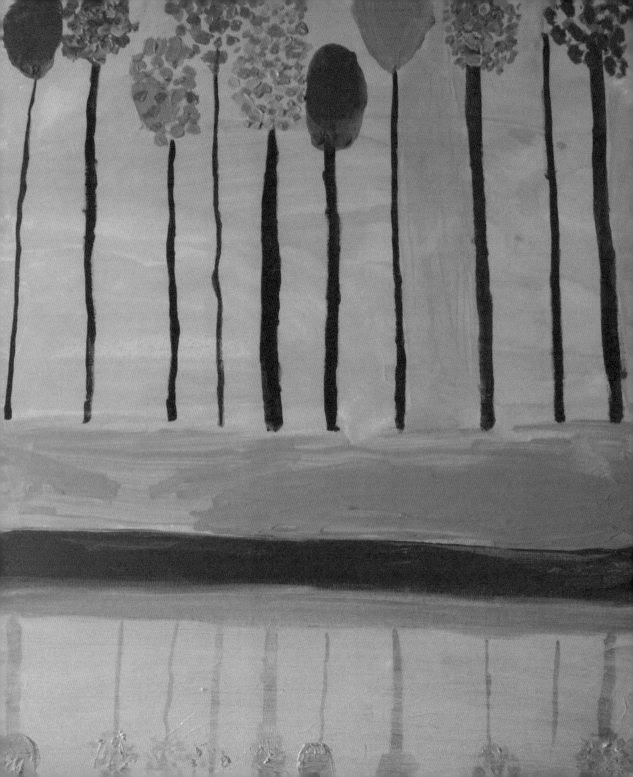

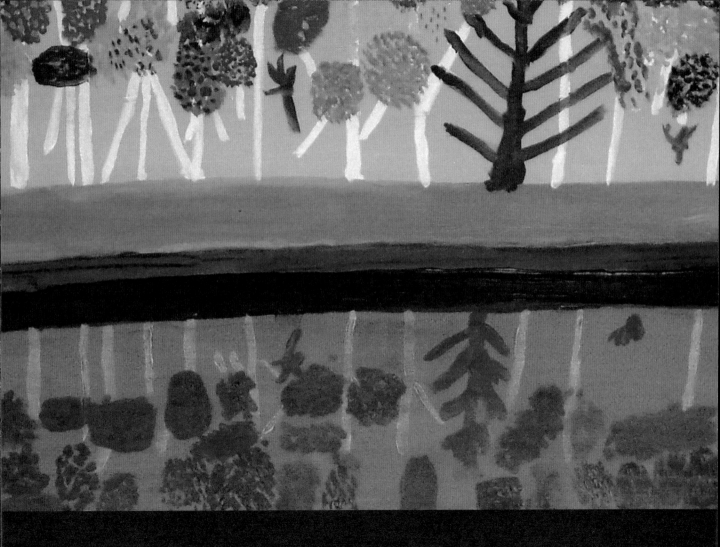

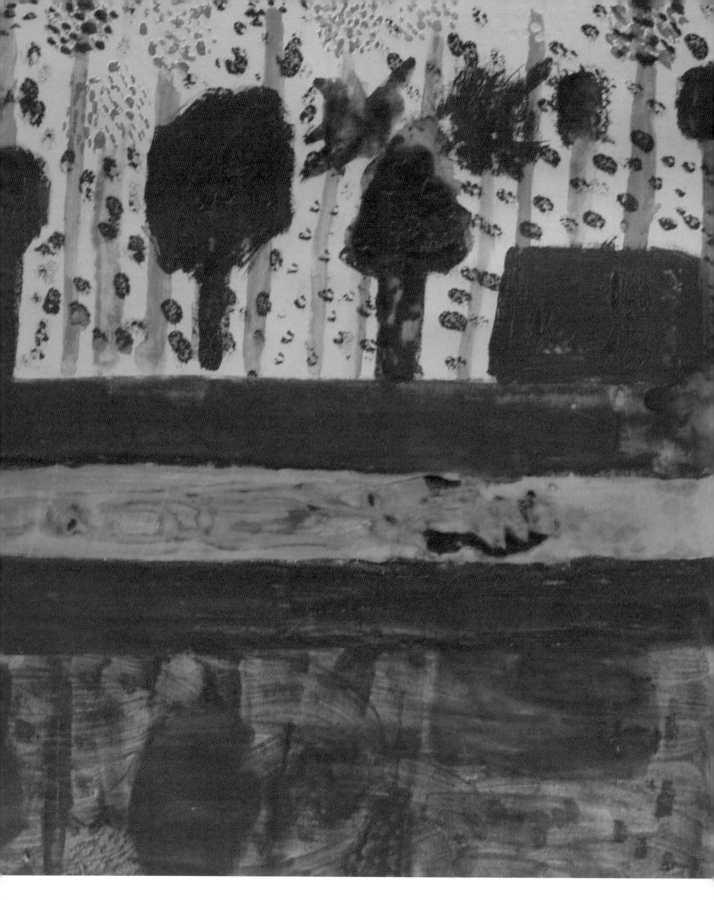

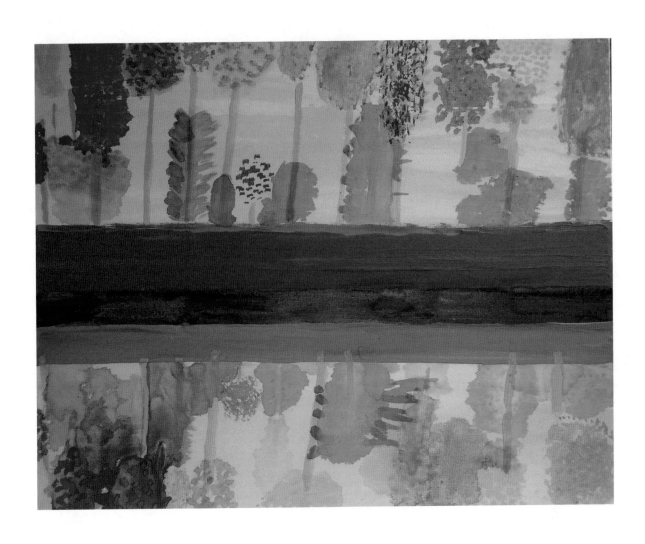

Pollution Pollution, 2009

Acrylic on canvas

Size 75 X 75 cm

Mirky Waters, 2009

Acrylic on canvas

Size 60 X 60 cm

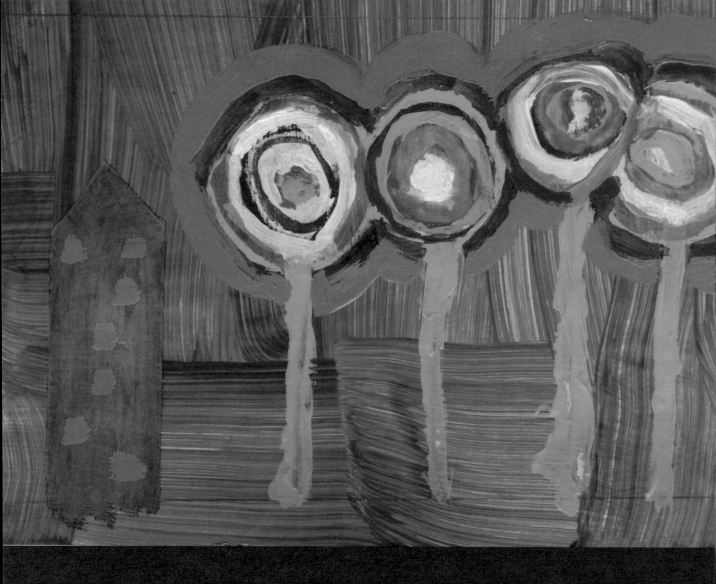

These flowers start off small and colourful - they get whiter when they get less and less water and sun and then they get closer and closer to dying. I would prefer to paint happy flowers than sad ones, so let's stop climate change now!

Sad Flowers, 2009

Pastel on paper

Size 29.7 X 21 cm

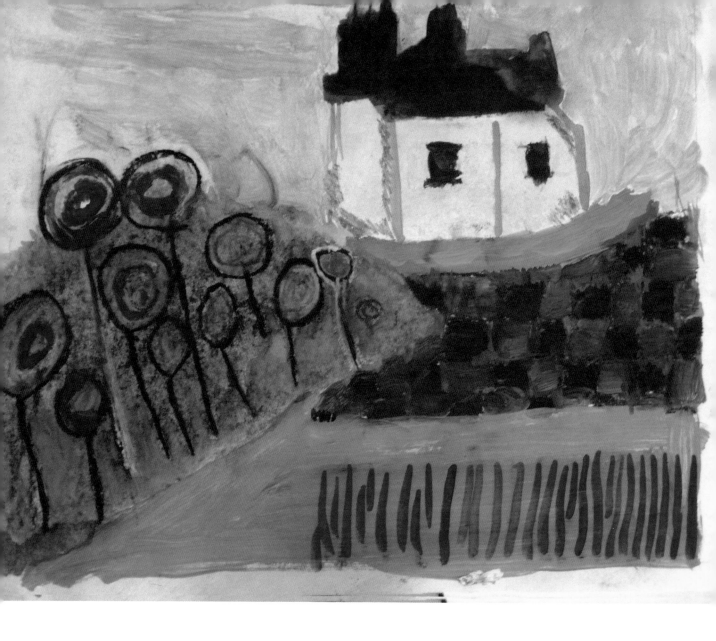

House On Hill, 2009

Pastel on paper

Size 30 X 21 cm

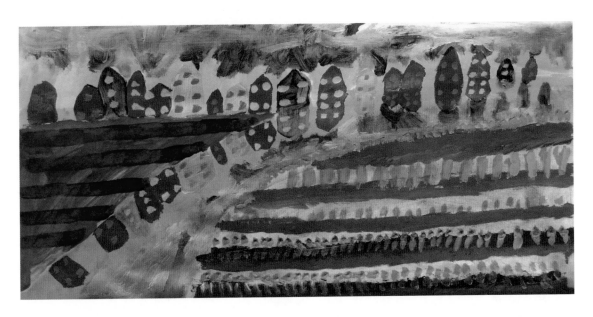

Fertile Lands, 2009

Pastel on paper

Size 40 X 21 cm

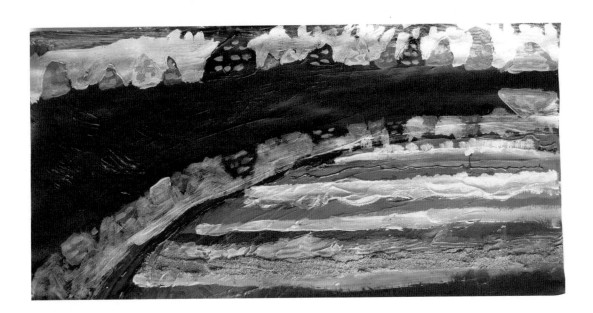

Bare Lands, 2009

Pastel on paper

Size 40 X 21 cm

Queen Elizabeth Simple Garden, 2009

Acrylic on canvas

Size 59 X 50 cm

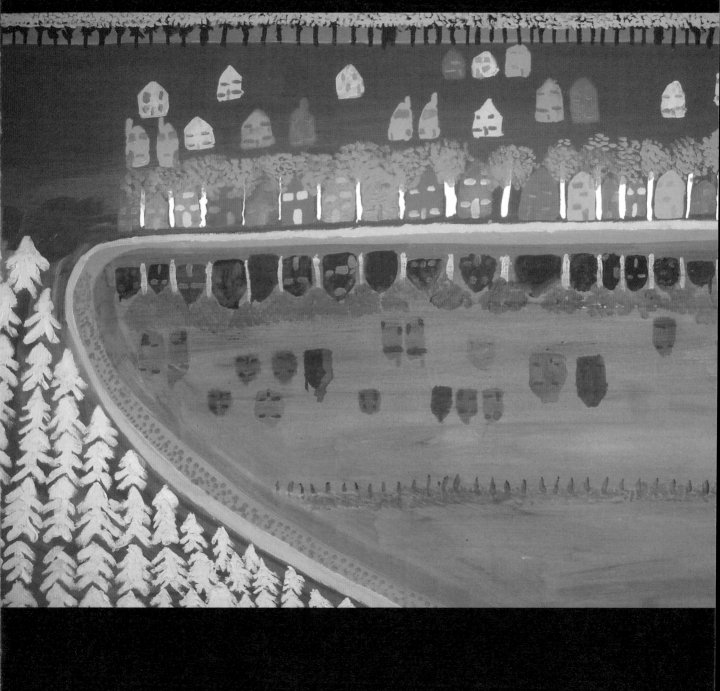

A Temple Rising Above Pollution, 2009

Acrylic on canvas

Size 70 X 120 cm

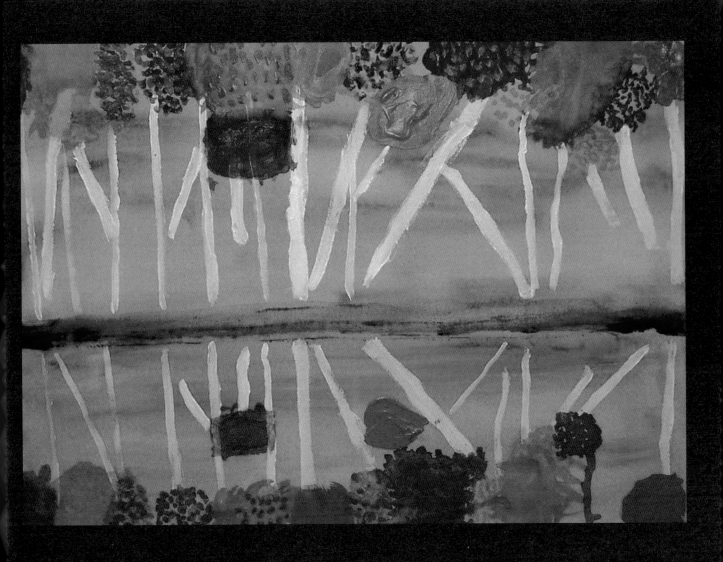

A Sad Forest, 2009

Acrylic on canvas

Size 60 X 50 cm

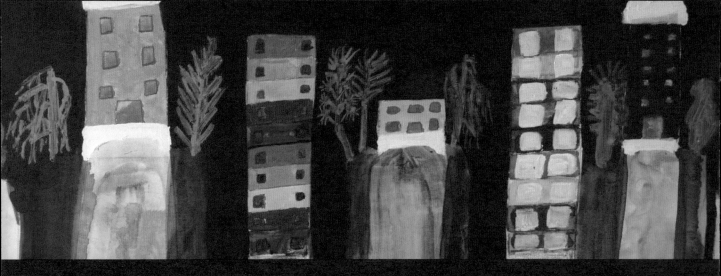

Social message

We need more "loveness" - so the whole world is happy at the end.

Imagine that our planet is not round but heart shaped - which means love.

We are in a race - a race to get all people in black and white houses into coloured ones as fast as possible. People are wanting the see the happy signs - that their houses are colourful and with views.

Serious

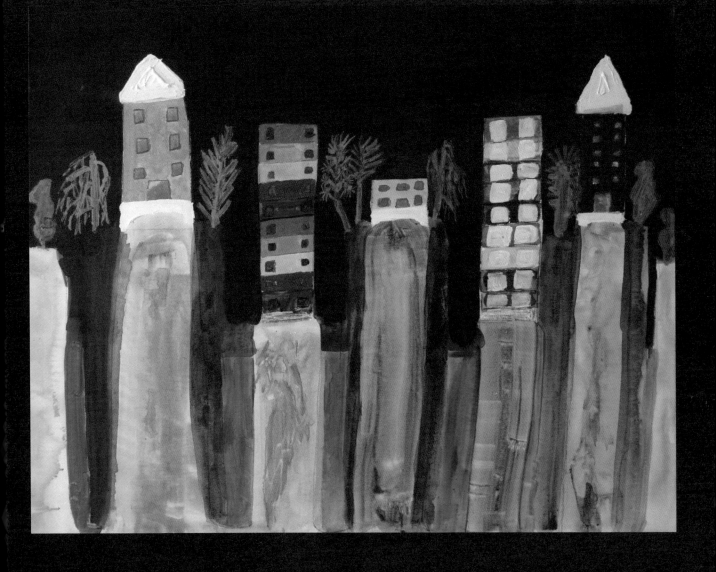

Houses on Mountains with Great Views, 2008

Acrylic on canvas

Size 100 X 80 cm

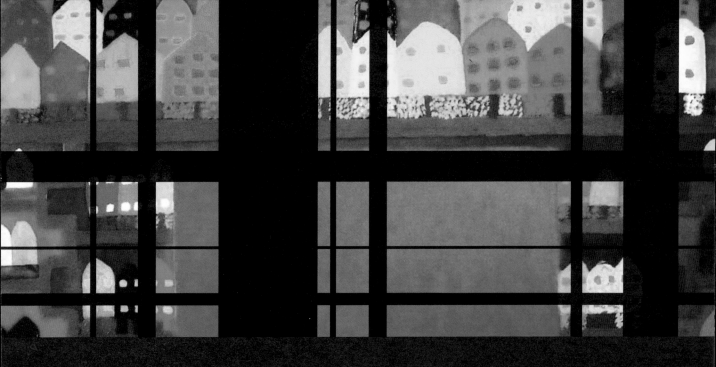

The multi coloured houses around the lake are an imaginary city - a dream city - where people live and want it to be beautiful - imagine a city where people would live in houses that are their favorite colour! This is not the way cities look today - where house are similar colours… mostly whites, beiges and grey.

I am talking here about getting the right mix between the past and future, what was and what can be - on the one hand, some houses have 'normative' qualities, on the other, they are painted bright colours for innovation - to risk new!!!

The rich people live in beautifully coloured houses with flowers in their gardens. They have a gorgeous view of the lake. Their houses are ornate with windows from where lights shine through. They are having a good time, they are having parties. You can almost hear the music from where you stand.

The poor people are just in black and white houses, and shades of grey in between and no gardens. There are no windows in the poor houses, their outlook is bleak.

The painting compares wealth and poverty and asks the question "will the rich people help their poor neighbours?" "Will they actually fish in the lake for them?"

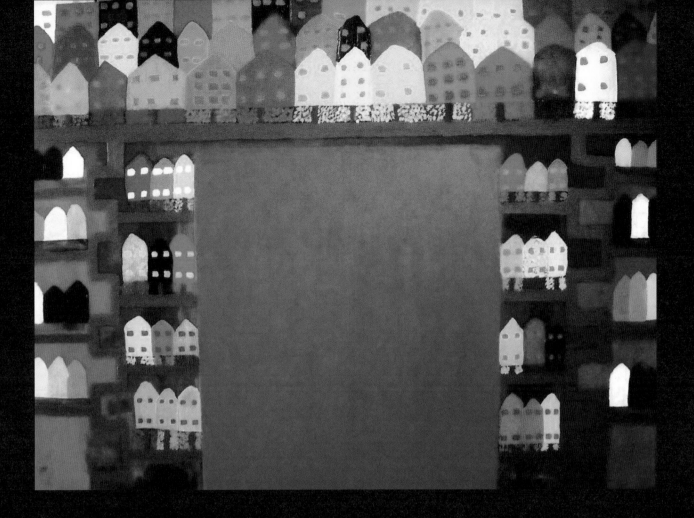

Houses of Rich and Poor, 2010

Acrylic on canvas

Size 120 X 70 cm

"Bella called the painting "My black and white life in colours". She said that she loved the rainbow colours building because those are the colours of the gay flag. When she looks at the rainbow building then she feels that it is her house and she loves it as opposed to the black and white building with the people who are not gay."

My Black and White Life in Colours, 2010

Acrylic on canvas

Size 120 X 70 cm

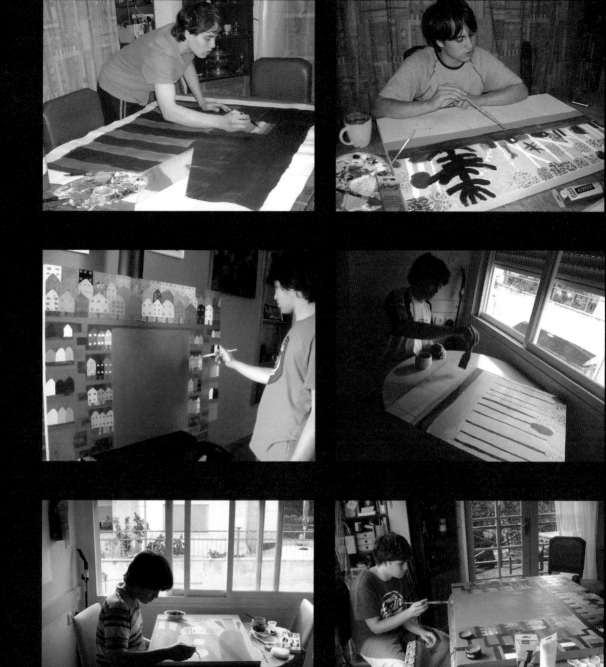

"Together" is about being separated from Marc and Seli who I love. I drew them in the middle and on each side of the print the kilometers between us.

Distance, 2008

Lino cut print

Size A3

My grandparents, Marc and Seli, are my first fans. They loved the painting I made for them right away, and lend it to be exhibited when we have an opening near them. This painting is about a Bahai temple with a golden roof... the first time I saw it was in a book in the high school library.

Marc and Seli watch me painting and are impressed and fully support my decision to become a professional painter. They spoil me - maybe because I am their youngest grandchild?

Marc and Seli Jancourt and Yaniv Janson, 2008

FEATURED
ARTISTS
CHERIE S
- Y·ARTISM
YANIV JANSON
·ARTIST IN RESIDENCE

Permanent Installations

Galerie Clin. Butnaru, "Climate Change in Prints", Place de Mexico 75016 Paris, France
[solo exhibition from May 2010]
GreenSpace, "Climate Change - Change NOW!!!", Hamilton East, New Zealand [since March 2010]
Momento, "Who's Afraid of Climate Fluctuations?", University of Waikato Management School, Hillcrest,
New Zealand [solo exhibition, since January 2008]
Waikato District Health Board: 'Apocalypse now' [in the WDHB Library since March 2008], New Zealand
Waikato District Health Board: "Sue's t shirt" [Transfusion 2009 competition], New Zealand

Solo Exhibitions

Dec 10: Galerie Celal, "Visions des Antipodes", 45 Rue St Honore, 75001 Paris, France
Oct 10: Wallace Art Gallery, "Climate Chains", Morrinsville, New Zealand
Sept 10: ArtsPost, Waikato Museum: "Visualising Climate Change", Hamilton, New Zealand
May 10: Bet Abba Hushi Cultural Centre: "The Joy of Colour", Haifa, Israel
Dec 09: Pomegranate Gallery, "It is me", Hamilton East, New Zealand
Oct 09: Cafe Gallery Ein Hod, "Climatic Perspectives", Ein Hod Artist Village, Israel
June-Aug 09: Hillcrest High, Hamilton, New Zealand
Aug-Sept 08: Tamarillo Gallery, "Natural Worlds", Wellington, New Zealand
May 08: La Commune, Hamilton [silent auction], New Zealand
April 08: SANDZ Gallery, Frankton Village, New Zealand
April 08: Momento (Lakeside venue), University of Waikato, Hillcrest, New Zealand

Group Exhibitions

Oct 10: Macalisters Art Award, Annual Spring Exhibition, Anderson Park Art Gallery, Invercargill
Sept 10: Bantham Gallery, "Creativity Square", Waikato Society of Arts Member Exhibition, Hamilton
April 10: Wellington Convention Centre, "Building Bridges", Wellington
March 10: ArstPost, Waikato Society of Arts Members's Exhibition – A Passion for Art, Hamilton
Sept 09: Great Waikato Art Show, Hamilton
Sept 09: Waikato Society of Arts, 2009 National Youth Art Award, Hamilton [finalist]
July 09: SANDZ Gallery, Telecom IHC Arts Awards 2009, Hamilton
July 09: Waikato Museum & Waikato District Health Board, Transfusion, Hamilton
Feb 09: Right Bank Arts Festival, Waikato Society of Arts, Hamilton Gardens
July-Oct 08: The Wallace Foundation, Salon des refuses Auckland [17th Annual James Wallace Trust Art Awards finalist]
Oct 08: The Molly Morpeth Canaday Art Award and exhibition, Whakatane
Sept 08: Thornton Gallery, Waikato Society of Arts WAIPRINT 2008, Hamilton
Aug-Dec 08: Waikato Museum, [Trust Waikato National Contemporary Arts Award finalist]
July 08: SANDZ Gallery, Telecom IHC Arts Awards 2008, Hamilton
July 08: OSFA "One Size Fits All", Thornton Gallery, Hamilton
June 08: ArtsPost, Waikato Society of Arts Members Exhibition 10 years at ArtsPost [2 paintings exhibited]

Multimedia Exhibitions

June-Sept 09: Waikato Museum, Claymation workshop video "The artist within" [co-created with A. Janson]
April 09: Te Papa Museum of New Zealand, 'Our Space', Wellington

Photographer: Shane Mortor

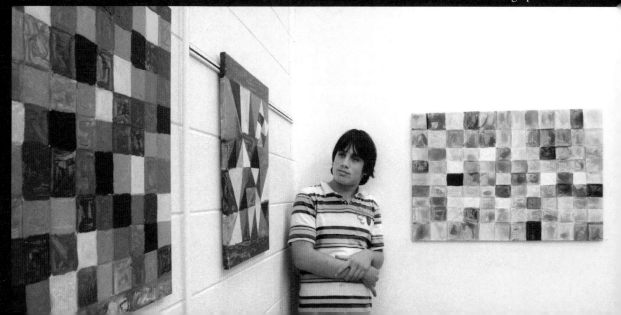

Awards

2011 Arts Waikato Scholarship
2010 Finalist: Recognyz Youth Awards (Youth Council/Hamilton City Council)
2010 Eleos Trust Award
2010 Variety - Gold Heart Scholarship
2010 Wheeler/McIvor Scholarship
2009 Highly Commended Award: Great Waikato Art Show
2009 Finalist: Recognyz Youth Awards (Youth Council/Hamilton City Council) Arts category
2009 Finalist: Waikato Society of Arts, National Youth Art Awards
2008 Finalist: Trust Waikato National Contemporary Arts Award
2008 Finalist: 17th Annual James Wallace Trust Arts Award

Publications

2010 Changing the World - One Painting at a Time, EGL Ed: USA paperback ISBN-10: 1451547013
2009 Yaniv Janson, PortFolio, Ecosynergy Editions: USA paperback ISBN-10: 1449512933
2009 Hamilton Artists Directory, Hamilton Community Arts Council publication. p. 12.

Media

2010 TV Central News, Interview with Yaniv Janson on sustainability art practice [20 Sept; 7:30pm]
 Waikato Times, Waikato artistic efforts rewarded, News, p. A7 [18 Sept]
 Stuff.co.nz, Local youth to be celebrated at Recognyz Awards, Scoop News [13 Sept]
 http://Hot-Topic.co.nz Global warming and the future of New Zealand Blog, Paint it Bleak [9 Sept]
 http://sciblogs.co.nz Science Media Centre Blog, Royal Society of New Zealand [9 Sept]
 Radio New Zealand, Our Changing World, Visualising Climate Change Exhibition [2 Sept]
 Hamilton News, Climate change visualised through art, p. 15 [3 Sept]
 Hamilton Press, Yaniv – an early achiever, p.13 [1 Sept]
 MSN New Zealand, Young Kiwi artist inspires change, Cleo Magazine [30 Aug]
 ArtSpace, Hamilton Community Radio, Interview with Yaniv Janson [26 Aug]
 Hamilton News, Gold Heart Scholarship for Hamilton high fliers, p. 4 [1 July]
 Haifa and Northern News, The Joy of Colour Exhibition, p. 28 [18 May]
 Hamilton News, Quiet teen expresses a unique world view, p.9 [8 April]
 Eastsider: A Hamilton Community Publication, Issue 21, p. 4 [4 April]
2009 Hamilton Artists Directory, Hamilton Community Arts Council publication. P. 12 [28 Dec]
 Waikato Times, Sensory delight - The new drill. Arts Section, p.17 [24 Dec]
2008 Waikato Times, Waikato talent eying award, Arts section, p. 10 [21 Aug]
 Arts Monthly, Y-artism exhibition tour [1 May]
 Hamilton Press, Talent unleashed, p. 6 [16 April]
www.y-artist.blogspot.com website featured on the websites of the Hamilton Community Arts Council, Arts
Waikato and Waikato Society of Arts. , DIGITALNZ A-TIHI O AOTEAROA, Te Papa Our Space and
www.newzealand.com

Artist in Residence

Making a film, one shot at a time
By *John Mandelberg*
Lecturer in Moving Image, School of Media Arts, Waikato Institute of Technology & Bluewater Productions: Photography and film projects development, Hamilton, New Zealand.

It's hard to juggle the roles of teacher of Moving Image in a Bachelor of Media Arts course and a documentary filmmaker, let alone find a subject for a film that is close to your heart and at the same time exciting, interesting and a subject that you can live with for months and sometimes years. Although the film you make will always be part of you.

So in 2008, high school student Yaniv Janson started to paint seriously for the first time since he was at kindergarten. His work was starting to be shown at public exhibitions, cafés and small galleries. In May 2008, my film making partner Janice and I went to an exhibition at La Commune café in the main street of Hamilton, where his paintings were hung all over the walls. The opening event had a family and friends feel about it, and we bought two paintings. The work was really exciting, with a beautiful and intuitive sense of colour and balance. It was naïve and to me somewhat reminiscent of the paintings of Austrian artist, Paul Klee.

Photographer: Janice Abo Ganis

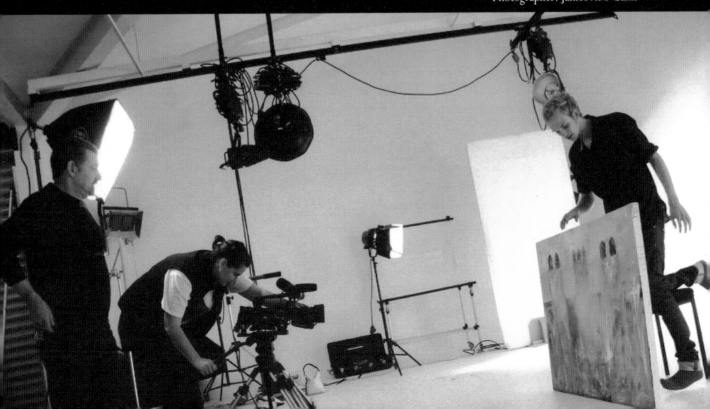

Being friends of the Janson family meant that we were kept informed about the number of exhibitions of Yaniv's work that were starting to take place regularly. Then much to our surprise we were invited to the opening night of the 2008 Trust Waikato Contemporary Arts Awards where a painting by Yaniv was selected as a finalist. It was that night, after chatting with family and friends and looking at the range of the finalists' work, that I thought "here's a great story", and I told Annick, Yaniv's mum that I would love to make a film about him.

Starting any film project is a daunting act, particularly when you have no idea as to the final outcome. Undeterred, we started working almost the next week. I asked Samarah Wilson, a recent graduate student of mine from the Media Arts course at WINTEC to be the cinematographer and to collaborate with me on the project. I also discovered that Sam had a connection with Yaniv through her mother. She had been a teacher in the special needs class at the high school where Yaniv was attending.

We started filming on a rather sunny Hamilton day with Yaniv, Rob (Yaniv's father) and Annick at the Waikato Museum where we proceeded to film them as they strolled around the Awards exhibition with Yaniv commenting rather acerbically on the finalists' work, and then looking at his own work on display. We also filmed Yaniv in Auckland at the Wallace Art Gallery, where his work was hanging with other entrants for the 2008 Wallace prize. Here he talked about his work and he rated the other works he liked in the gallery.

From then on we filmed a range of sequences and interviews to include in the documentary - interviews with Annick and Rob about Yaniv's life to date. We shot sequences of Yaniv bringing new canvasses home, and painting sessions right on the Janson's dinner table. This was the place that Yaniv felt most comfortable working.

Over the next few months we filmed the family together at a Sabbath evening meal, Yaniv taking the loop bus ride around town, Yaniv in a park blowing soap bubbles (an amazing ability he has had from childhood). We also interviewed Yaniv's art mentor Marcel, about how he has been working with Yaniv to develop his skills and discussed with him the range of work produced by artists with disabilities.

As the material slowly rolled in, I started editing together the interviews with Rob and Annick to shape the story of how Yaniv became a finalist in these two National Art Awards. I scanned the large collection of family stills documenting Yaniv from birth in Israel until today living in Hamilton, New Zealand, to use as visual background material to help with the telling of his story.

How to document his developing painting skill was important, but I didn't want to create a straight chronological narrative through his works or even his life. So Samarah suggested we film several groups of his paintings in a white infinity space studio and put the work in a line and track past them slowly so we could see the range of styles, colours and themes. I also had in mind some music (from the film by the Russian composer Alfred Schnitke) to edit some of the sequences, which would equate with the simple style and colour of the works. Subsequently, composer David Sidwell synthesized the ideas within the documentary and the flavor of the music, to develop a score for the film that matches mood, style and quality of the narrative.

The piecing of the images together is not just like resolving a picture puzzle from the image on the puzzle box, but an intricate weaving of the image, sound and interrelationships formed with the material, as you use words or images to propel the story forward. The story is told through the memories of Rob and Annick, the narrative moves back and forward in time revealing much of Yaniv's life story and his work to date. Yaniv's brother and sister, Stephane and Melissa, Marcel, the Learning Connexion mentor and Yaniv himself, all tell aspects of Yaniv's story and their relationship to him and his developing skills in painting. I was able to link all these ideas together in a flow that moves seamlessly as the documentary story is told.

We also filmed Yaniv at school working on a project from the Learning Connexion Distance Learning programme, and a sequence in a cooking class with Yaniv icing some chocolate muffins he had made - all the while talking about what he would do with the prize if he won a particular art award. Yaniv is obsessed with entering competitions from the back of cereal box tops, from biscuit and soup labels, and it is this penchant that led him to enter the Waikato and Wallace National Art Awards.

We have had a hiatus of almost 6-8 months between filming each of the major segments for the film, as both Samarah and I have had to do paying jobs whilst making this film. However, this has been to the advantage of this film making and we have benefitted from having a longer period than normal when making a "portrait of the artist" documentary to watch Yaniv develop, flourish and grow through the months and now years that we have been making the film.

At the time of writing, the documentary film runs around 40 minutes and isn't quite complete. However, Yaniv's story is ongoing; he is only 18 years old and has a long and full life ahead of him as an artist. He might stop painting tomorrow or continue through adulthood to old age, who knows? His work appeals to a great number of people, from the evidence that just about all the works he paints are snapped up by family, friends and new admirers who see his work on display.

We are now poised to film Yaniv at his one man show "Visualising Climate Change" Paintings at ArtsPost in September 2010, right next door to the Waikato Gallery where this project originally started. In the next few months I will finish editing this journey through Yaniv's life (to date) and often wonder what he will be doing in 5 years time. Perhaps he and his family will let me back in to make another film about this marvelous young man, his family and his art.

Words from the Waikato Museum Director

Over the past five years I have contributed a statement each year to the Trust Waikato National Contemporary Art Awards exhibition catalogue expressing the Museum's continued enthusiasm and support for the event. This year my statement is written with a particular sense of excitement and anticipation in the air generated by the city's new Creativity & Identity Strategy, which challenges us to be 'bold and imaginative' and to 'foster creativity and imagination'. This exhibition meets the challenge exceptionally well, providing a unique space for experiencing contemporary art and culture, whilst pushing at the boundaries of innovation, creativity and expression. We are proud to host an exhibition that encourages artistic innovation and celebrates 'art at the edge'.

The exhibition is never 'easy' and regularly attracts controversy and creates a sense of unease with patrons. However, any change in 'seeing' and 'understanding' often requires some stretch and discomfort. If the exhibition creates more questions than answers and encourages us to explore our perceptions and understandings, it is succeeding in its objectives.

Naku noa na

Kate Vusoniwailala
2008

WAIKATO TALENT EYEING AWARD*

Trust Waikato National Contemporary Art Award August 22nd - November 20th

A word from the Judge

It shouldn't be a surprise that this year's finalists have thrown up some strong contenders in the areas of painting and photography. As diverse as they are to one another, these works articulate an ongoing interest in wall-based image making. Even when the primary motivation is a performative action, a relationship with location or an object, the idea has been resolved on the wall, in the now-neutral format of picture making. In this context, those artists working in three-dimensions also appear to be picture making in sound and space.

Many of these artists reveal their sophisticated and long-term engagement with the process of art making. Others have provided genuinely engaging platforms for their personal, conceptual and aesthetic enquiries.

In selecting the finalists I have focused on works that are instilled with the qualities of curiosity. Sometimes provocative sometimes subtle, these are objects and images which invite speculation, not only as to their physical and conceptual natures but also to their intention. In these terms they may be at once familiar and inviting while equally disruptive for our senses. All in all, the best of these works show a visual intelligence and a capacity for translating the multifarious domain of ideas into form.

Natasha Conland, 2008
Curator Contemporary Art, Auckland Art Gallery

* From the Waikato Museum 2008 National Contemporary Art Award Catalog.

How I met Gosia Piatek, the fashion designer, was in the lobby of the Duxton Hotel in Wellington, right by the entrance. We all started speaking together and I answered her questions. She looked very nice to me – the way she spoke to us and looked at us – and her smile! I could not imagine what my design would look like on a tee-shirt!

When I first painted the planets, the design that she chose, I painted them from the smallest to the biggest one. I added their names in because not everybody is 100% positive what planet is called what.

I thought about the fact that some people have other favorite planets then Earth and they do not see them unless they are astronauts or they can see with cameras that see the furthest out of Earth and into the solar system.

Photo supplied by Gosia Piatek, Kowtow Clothing, Organic FairTrade, www.kowtow.co.nz

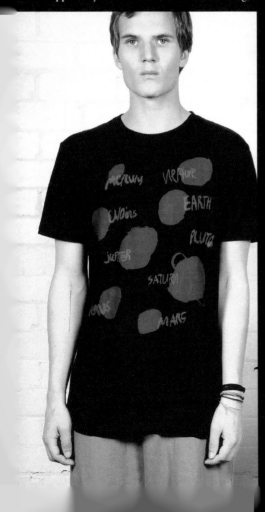
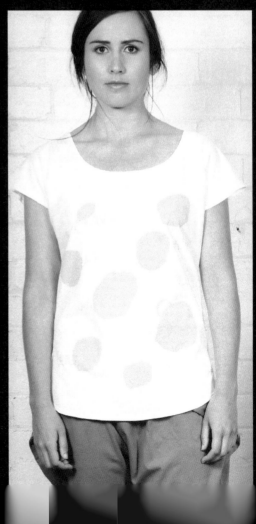

MERCURY

NEPTUNE

URANUS

EARTH

PLUTO

JUPITER

SATURN

VENUS

MARS

85

What I like about bubbles - they are my favourite shape.
Their colours - change texture, at the beginning they are green and pink and after that they are rainbow colours
for a while. By the very end they turn black and white - or transparent and you can't see them except
when you are facing the clouds and you see the white bright clouds.

At the end sometimes they disappear and are transparent.
Sometimes you see them pop and when they do, the sound they make is so lovely. Sometimes they pop like tiny
water bombs and so many little parts fly all over the place like sprinklers - LIKE THAT!!!

This picture was taken a week after we moved to New Zealand in 2000.

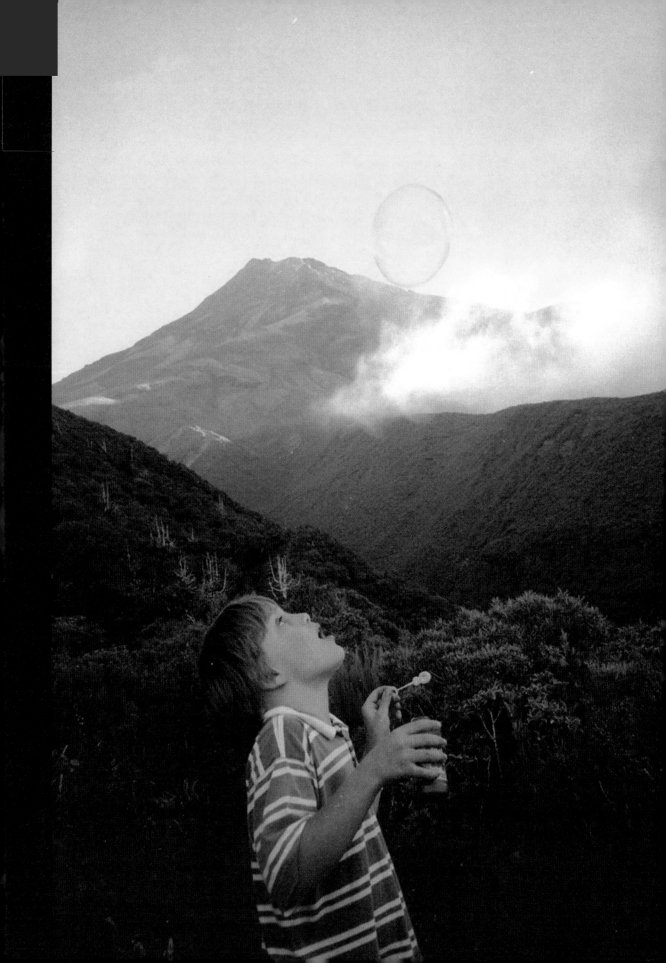

Quiet teen's unique view of the world – Green issues expressed through art

Janine Jackson, Hamilton News 8 April 2010

Young Hamilton artist Yaniv Janson is a young man of few words but his art speaks volumes.
He hopes his painting will have an impact on people and they will think about the effects of climate change.
One painting— How much longer till the water rises?—depicts buildings slowly being swallowed by the sea and questions the viability of lowlying countries.

Yaniv launched his first book Portfolio at the Pomegranate Cottage opening in December 2009 and in April he will exhibit at Groundwork Associates, an organization active in the field of climate change and sustainable resource management.

International exhibitions in Paris will follow in May and in Israel later in the year.

An upcoming solo exhibition for ArtsPost later this year will also coincide with the international launch of the documentary Changing the world —one painting at a time filmed by John Mandelberg (Wintec) and Janice Abo-Ganis (Bluewater Productions, a Hamilton-based documentary company) and the publication of a book on painting as political activism.

Painting speak for young Hamilton artist

Janice Jackson, Eastsider, 4 April 2010

As well as finding creative expression through his art, Yaniv also conveys a political and social commentary.

His latest exhibition dubbed Climatic Thoughts at The Pomegranate Cottage in Hamilton East tells a story of global warming. Like many his age, Yaniv is deeply affected by environmental issues and chooses to express his discomfort through his art. "It's about water rising, the ice melting and some countries getting hotter," he says. "You hear in the weather (news reports) how much of the North and South poles are melting."

Talent unleashed

Geoff Leuuis, Hamilton Press, 11 April 2008

Yaniv Janson is turning art into a business [to follow his passion for art] … he is a leader for his peers and inspires them [to reach more heights]

"Sensory delight" the new drill
Rob Kidd, Waikato Times, 24 December 2009

17-year old Yaniv Janson had a very successful opening night at the Pomegranate with 21 paintings in the exhibition three of which sold… His work focused on climate change and it struck a chord with many of the audiences. …The aim of this (new exhibition) space is to provide "sensory immersion" giving visitors paintings, jewelry and gourmet food to view, touch, taste and enjoy.

Waikato talent eyeing award
Matt Bowen, Waikato Times-Arts, 21 August 2008

Prepare to be challenged, inspired and even a little uneasy.
Finalists in the often controversial Trust Waikato National Contemporary Art Award have been named and the winner named tomorrow night. Among the nationwide talent pool are three Waikato artists; 16-year-old Yaniv Janson is one of them. The Hillcrest High student was born with Asperger syndrome – an Autism Spectrum Disorder characterised in part by intense absorption in a special interest. Austrian Hans Asperger discovered the condition and dubbed his four young patients "little professors" due to an in depth knowledge of their favourite topic. In Early 2008 Yaniv suddenly and adamantly started to paint. And he has already encountered considerable success. I've sold 34 paintings to date and people from Gisborne and Wellington have called to get hold of them," he said. He was also named as a finalist in the 2008 James Wallace Award with his work "Life, the universe and everything."

Prizes for the competition amount to $70, 000, something Yaniv is very aware of – he plans to make art his profession.

"I want to prove to my parents and everybody that I can do this for a living. I don't want a real job, I want to paint." he said. The aspiring artist submitted his entry 'Autumn Reflections' in person at Waikato Museum and is very excited at the prospect of pocketing the $15, 000 winner's cheque. The current curator of contemporary art at the Auckland Art Gallery based her choices on works that inspire curiosity. "Sometimes provocative sometimes subtle, these are objects and images which invite speculation, not only as to their physical and conceptual natures but also to their intention," she said. "In these terms they may be at once familiar and inviting while equally disruptive for our senses."

Waikato Museum director Kate Vusoniwailala agrees that the exhibition is about challenging audiences.
"The exhibition is never 'easy' and regularly attracts controversy and creates a sense of unease with patrons," she said. "However, any change in 'seeing' and 'understanding' often requires some stretch and discomfort. If the exhibition creates more questions than answers and encourages us to explore our perceptions and understandings, it is succeeding in its objectives."

I love going to libraries.

If it is the Hamilton Central library, then I start by taking five books about art and after I finish looking through them, I take another five. The nicest way to read a collection of books is to go through them five at a time, instead of one at a time.

I browse through each book on the shelves, and if I see five pictures in the book that are interesting to me, then I select the book in the first pile.

I always sit on the very top floor of the library, by the window so I can see the view from the buildings and the shops.

In libraries that don't have a great view, I choose the most comfortable couch!

My favorite painters are Frederick Hundertwasser and Claude Monet and a few others.

Teacher Resource Appendix

Compiled by Dr. Annick Janson, Educational Psychologist and researcher

According to the New Zealand Curriculum, schools are required to support their students in developing five key competencies:

a) Thinking
b) Managing self
c) Using language, symbols, and texts
d) Relating to others and
e) Participating and contributing.

Teachers plan how to integrate these key competencies into the learning programmes they provide. Educational settings where art can be included are rich in opportunities to develop, practice, and demonstrate the key competencies in a range of contexts within and across learning areas, for instance environmental topics.

Authentic contexts are essential for developing the key competencies. Students need to apply the key competencies and use them to inform their learning. They are a means of transforming the way in which students engage with and put their knowledge and understanding into action. Attitudes are important as well as knowledge, skills, and values. Practicing environmental art in and beyond the classroom prompts students to demonstrate that they are ready, willing and able to use the new competencies they are cultivating . Hence, the role of teachers is to craft educational situations in which students are given opportunities to use the key competencies.

This pedagogical practice is about:
 * Focusing inquiry: teachers think about their students' learning needs and aspirations;
 *Teaching inquiry: teachers reflect on the teaching approaches they intend to use;
 * Learning inquiry: teachers take into consideration the impact previous teaching has had on their students' learning.

Visual Arts to Develop Key Competencies about Environmental Issues

Thinking

The Thinking Key Competency is about using creative, critical and logical metacognition, reflection and judgment. Students integrate cognitive, and rational, emotional and sensory forms of thinking in ways that can be analysed using taxonomies such as those derived from Bloom's classification. Students critically analyse visual and written information about selected art works and their related social and environmental issues. We can categorise activity from lower order to higher order thinking and use the same tools adapted to understand the thinking processes at play in the Visual Arts.

These illustrations show the various stages of Yaniv's thinking processes – from simple to complicated, from minimalistic to complex, juxtaposing contexts and symbols to enhance impact. The description of complexity can be two dimensional (as in a puzzle), three dimensional (as in a cube) or even multidimensional as in chronologies where time sequences are used to visualise the dangers of climate change (for instance on the fragile ecosystems of the oceans). In the fish series, the concept of the dangers of the unknown effects of global warming is conveyed by juxtaposing two paintings with one devoid of fish - we just don't know…

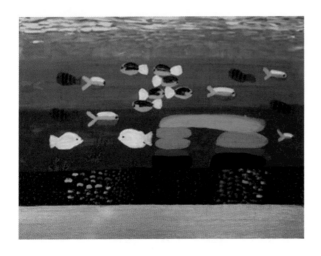
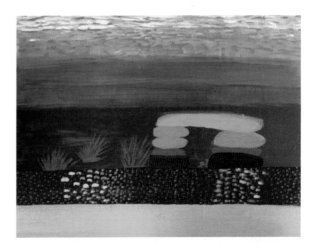

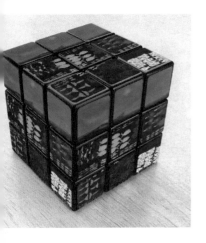

Using Language, Symbols, and Texts

This Key Competency helps students make meaning from everyday physical and emotional experiences; students will make meaning from the symbols and texts they are presented with, as well as use symbols to produce their own visuals. Visual Arts is unique as a 'way of knowing' and understanding others and the world, and students can use a variety of media and technologies to communicate environmental messages.

These illustrations show how Yaniv used a variety of media and dimensions to express his ideas. This was all the more important because he found it hard at first to express his ideas in words. "Free the artist within" is a claymation production that represents an interaction between life and dreamtime, which is then transformed into digital media: the artist's dreams take him to places where the environment is suffering, prompting him to paint works for art competitions, thereby spreading the message to more audiences. Art afforded him the opportunity to express ideas with images and colours, to juxtapose visual symbols and express more complex ideas, creating added impact. Smart use of the technology allows for messages to travel further (as in the example of New Zealand Digital Repository). Using multimedia opens new and exciting possibilities, such as the exhibition in the "Our Space" gallery at the Te Papa museum, New Zealand's National Museum, a 'physical' exhibition that receives its own URL for distribution. Technology also enrols Avatars, who in this case curate and offer a guided visit to a virtual gallery.

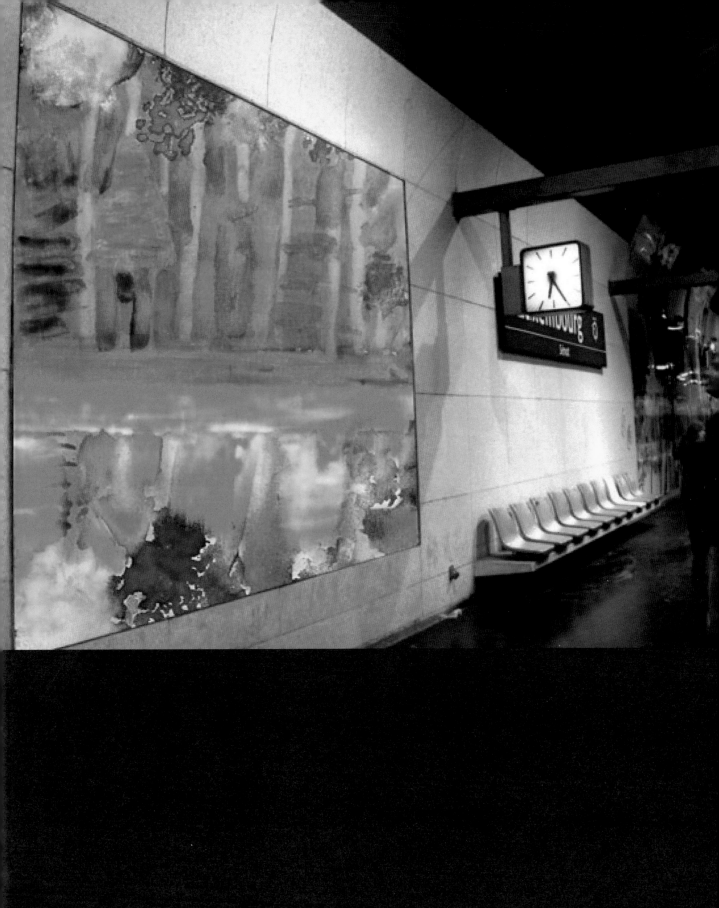

Managing self

Managing self is acting acting autonomously to handle a process whereby the structure and form of art works comes from chaotic creative energy. Students work to make plans, set goals and work by deadlines.

Research has shown that students use art to structure the chaos and disorder of their own lives, and beyond that, build a professional career. For a person with Aspergers syndrome, managing self in the public sphere is daunting, but Yaniv's passion for art has helped him overcome many barriers. These illustrations show how art was the impetus to become famous, motivating him firstly to get recognised nationally. Because showing his art was important, Yaniv ventured out of his comfort zone, and has become accustomed to making public appearances, each time 'risking' more and consequently making more progress. He further extended his autonomy by carrying out new activities such as meetings with professional designers keen to collaborate with him on public art projects (such as the creation of an installation for the New Zealand Clean Energy Centre), and on fashion projects (such as exhibiting his art on clothing). Yaniv also worked with a large corporation designing for an event (Microsoft New Zealand, Partners in Learning project). These projects involved complex planning such as working to deadlines or presenting completed art ready for exhibition. Book signing was an important activity to launch not only his books but also a well-earned autonomy.

Relating to others

Relating to others is taught most directly in the classroom by the relationships between student and teacher and student and student. Students can interact with their classmates in small and large groups to investigate environmental information. Students also develop communication methods in relation to specific audiences.

In order to fulfil his dream, Yaniv had to develop new communication strategies that allowed him to talk to keen audiences of all ages and walks of life in order to describe his art. This is no simple matter for any teenager, let alone one with social and communication challenges. Art has allowed Yaniv to persevere and express messages in multiple visual ways and represent different points of view. Art proved to be the keyhole through which new knowledge and competencies could be channelled and through which social and environmental messages could be disseminated. Acting as this two-way conduit, his passion for art helped him gain recognition and respect and spread a unique message developed in a unique visual language. Communicating to others has been expanded to conducting meaningful interactions in a real life context.

Participating and contributing

The teaching relationships purposefully encourage active student participation and engagement. Teachers need to create an atmosphere that encourages student-to-student purposeful talk as they reflect and refine their own and others' work. Not only are students engaging in the co-creation of artistic work, but their contributions are valued and recognised in society. This implies that students are actively involved in community life and contribute to the social, cultural and environmental spheres of life.

A passion for the arts was the impetus to engage in meaningfully – real issues, real concern and a public willing to listen, led Yaniv to step into the public domain to speak out. His path took him from participation to social and environmental activism, from exhibiting art in galleries to political action in the public sphere. This engagement manifested itself through a willingness to expose his ideas a documentary filmed about him.

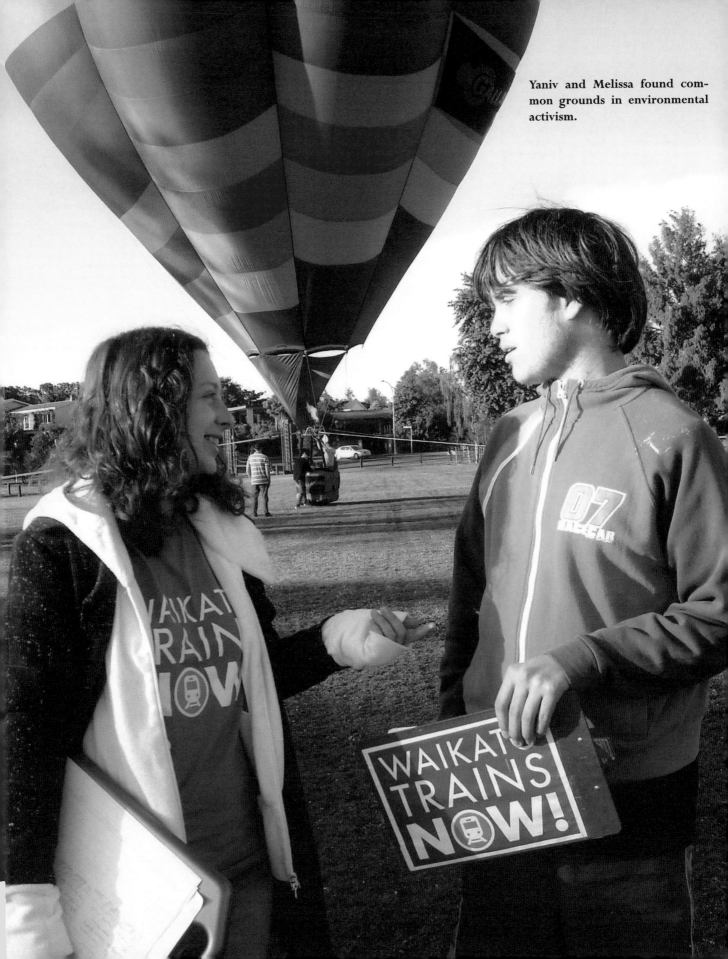

Yaniv and Melissa found common grounds in environmental activism.

The following is an example adapted from the http://artsonline.tki.org.nz website. Please see the TKI webpages for many more ideas in the development of key competencies using Art to raise environmental awareness.

DESCRIPTION OF UNIT

Students will research a range of art works and artists that address social or environmental issues. Students will then produce their own art statements to respond to a social or environmental issue that they wish to impact on.

CURRICULUM LINKS

VISION:

Connected - working in small groups, students develop an ability to relate better to others. Producing a series of art works that address social or environmental issues reinforce their relationship to their physical environment and community.

Actively involved – students grow the understanding of their statement as contributors to the social and environmental well being of their country.

Lifelong learners – researching and creating environmental and social art assists students in developing higher order critical and creative skills.

PRINCIPLES:

High Expectations – in the challenge to create activist art, student can find countless openings to strive for personal excellence in communicating ideas and growing technical skills.

Learning to learn – in reflecting on their learning paths, students are able to refine both ideas and art works.

Coherence - through the study of social and environmental issues, students make connections to other curriculum areas (particularly Science and Social Sciences).

VALUES:

Excellence - students are encouraged strive for achievements and act as role models.

Innovation, inquiry and curiosity - students grow critical, creative and reflective thinking capabilities.

Ecological sustainability - students become active promoter of ecologically sustainable practices.

ACHIEVEMENT OBJECTIVES	SPECIFIC LEARNING INTENTIONS
UC - Understanding the Arts in Context Research the potential impact of visual messages on political and social changes regarding sustainability matters.	Explore how art can be used as social and environmental commentary.
PK – Developing Practical Knowledge Use best practice for Arts and Environmental studies.	Grow tacit knowledge in the creation of art.
DI – Developing Ideas Initiate ideas and refine their inspiration in diverse contexts.	The particular topic of sustainability and other environmental issues serves as a real context in which to develop and disseminate visual ideas on how to understand and cope with these phenomena.
CI - Communicating and Interpreting Evaluate how ideas and art-making processes convey meaning through visual expression.	Discuss how ideas about social and environmental issues are disseminated through objects and images.

EXAMPLE OF REFLECTIVE ASSESSMENT TOOL (from the TKI website)

Key Competency	Considerations, opportunities	Your reflections, challenges and successes
Thinking	How have you used creative and critical processes to analyse images? What relationships have you identified between artists' ideas and their chosen techniques?	
Using language, symbols, and texts	Reflect on your own views - what ideas did you wish to communicate, and how did you use visual language and techniques to communicate those ideas. Discuss how ideas about social and environmental issues are disseminated through objects and images.	
Managing self	How did you manage your work in and outside of class time? Did you establish a time frame, work plan and clear objectives? Did you gather feedback, reflect on your progress? What are your next steps? How have they been informed by feedback?	
Relating to others and p articipating and contributing	How did you contribute to the class blog? Did you discuss ideas about your environment, your values, or reflect on issues? Did you give feedback to others and support development of their work? What feedback did you gather and how did it help you with your work?	

Name:

References

Anderson, L. W., & Krathwohl, D. R., (Eds.) (2001). *A Taxonomy for Learning, Teaching, and Assessing: A Revision of Bloom's Taxonomy of Educational Objectives*. Longman: New York.

The New Zealand Curriculum: http://www.nzcurriculum.tki.org.nz/The-New-Zealand-Curriculum

TKI New Zealand Ministry of Education relevant website http://artsonline.tki.org.nz/resources/units/making_comment/painting/student.php

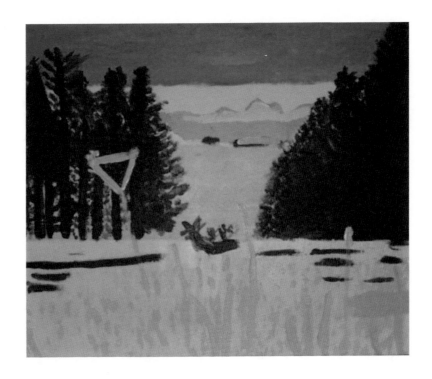

Pristine when again?, 2010

Acrylic on canvas

Size 59 X 50 cm

Made in the USA
Charleston, SC
27 May 2011